THE CUTTING EDGE FASHION FROM JAPAN

Edited by Louise Mitchell

ph|m powerhouse publishing
part of the Powerhouse Museum

First published in 2005
Reprinted 2006
Powerhouse Publishing, Sydney
PO Box K346 Haymarket NSW 1238
Australia
Powerhouse Publishing is part of the Museum of Applied Arts and Sciences
www.powerhousemuseum.com/publications

in association with

The Kyoto Costume Institute
Kyoto, Japan

National Library of Australia CIP
The cutting edge: fashion from Japan
Bibliography
ISBN 1 86317 114 2
1. Fashion design - Japan - History - 21st century -
Exhibitions. 2. Fashion designers - Japan - Exhibitions.
I. Mitchell, Louise, 1961- .
746.920952

The cutting edge: fashion from Japan © 2005 Powerhouse Museum, Sydney
ISBN 1 86317 114 2

Design: Danny Jacobsen*
Translations: Hiroko Moore, Japworks Translation and Interpreting Service and
SBS Language Services
Text editing: Anne Savage
Picture research: Linda Brainwood
Rights & permissions: Linda Brainwood and Gara Baldwin*
Project and production management: Julie Donaldson*
Image scanning: Ryan Hernandez* and Spitting Image
Printing: through Phoenix Offset, Hong Kong
Printed in China
* Powerhouse Museum (PHM)

The publication has been generously sponsored by

GORDON DARLING FOUNDATION

and supported by the Suntory Foundation

Distributed in Australia and New Zealand by Bookwise International
Distributed in other territories by Lund Humphries part of Ashgate Publishing

Published in conjunction with the exhibition *The cutting edge: fashion from
Japan* developed by the Powerhouse Museum, Sydney in association with
the Kyoto Costume Institute, 27 September 2005–29 January 2006.

Media partners Supporter

 marie claire JAPANFOUNDATION

(*Opposite*) *Origami pleat* textile, Reiko Sudo 1997 (see pp 82 and 83)

CONTENTS

FOREWORDS

The cutting edge: fashion from Japan expresses the Powerhouse Museum's commitment to fashion and costume as a unique form of creativity that links art with design. Fashion is too often viewed as essentially ephemeral, yet as a unique form of cultural heritage it provides an astonishingly accurate index of the style and social mores of the times. The Powerhouse has a proud history of exhibitions staged to bring the best in international and Australian fashion to the people of Australia. This dedication to showcasing design has allowed the Museum to work with, and bring together industry and community.

The cutting edge examines a significant moment in fashion history of the last 25 years by tracing the emergence and development of an independent group working outside the established traditions of international fashion hitherto dominated by European designers. While Rei Kawakubo, Yohji Yamamoto and Issey Miyake first established their international reputations in Paris, their garments draw on a distinctive and uniquely Japanese approach to style, cut and fabric that immediately set them apart. Their success in the 1980s opened the door to other designers from Asia and this exhibition reinforces the position of Japan as a major cultural force as well as charting the work of a number of significant younger fashion designers such as Junya Watanabe, Jun Takahashi and Hiroaki Ohya who have won international acceptance in the last decade.

Exhibitions like this draw on the Museum's own extensive fashion and costume collection and as well as the expertise vested in many of the Museum's staff, in particular Louise Mitchell, curator of the exhibition and editor of this publication. The exhibition would not have been possible without the generous assistance of Akiko Fukai, director of the Kyoto Costume Institute, who provided sound advice and great personal enthusiasm for the exhibition from the start. Indeed, loans from the Kyoto Costume Institute make up the majority of the exhibits in the exhibition, supplemented by material borrowed from Australian institutions and select private collections. I am most grateful to all of the lenders for their generosity and their confidence in the Museum's ability to safely travel, care for and effectively display their precious collections. *The cutting edge: fashion from Japan* exhibition and publication of striking and innovative Japanese design was made possible with the generous support, goodwill and civic spirit of the Japan Foundation, Suntory Foundation and Gordon Darling Foundation and our exhibition media partners *marie claire* and SBS Radio.

Dr Kevin Fewster AM
Director Powerhouse Museum, Sydney

The Kyoto Costume Institute (KCI) has been committed to collecting, preserving and researching historical Western costumes and contemporary works of fashion since it was established in 1978. With the clothes acquired over the years and its expertise developed through research efforts, the KCI stages fashion exhibitions in Japan and overseas featuring different themes and times of history. Particularly in recent years, it has become one of the central pillars of the KCI's activities to tell the world about the creativity of Japanese contemporary fashion in a global context.

We were certainly convinced that this new direction of our activities runs parallel to the world's interest but we felt reassured of this, not to mention honoured, when the Powerhouse Museum approached us for collaboration in *The cutting edge: fashion from Japan* exhibition. Since the last quarter of the 20th century, Japanese fashion design has been skilfully, and sensationally at times, overthrowing the standards of beauty, which had been dominantly Western, and remodelling them. It's been always one of the forces responsible for the de-Westernisation, or literally, democratisation of contemporary fashion. For those unfamiliar with the names like Issey Miyake, Rei Kawakubo or Yohji Yamamoto, it would only take a look at the Japanese fashion artists' creations to instantly recognise the magnitude of their influence on the designers currently successful in Paris or Milan. Naturally, the pioneers also have fostered remarkable Japanese talents including Junya Watanabe.

An exchange in aesthetics between Japan and the West can be found as early as the late 19th century in the movement of *Japonisme*, which is one of the main subjects of the KCI's research. A cultural phenomenon, in fashion or anything else, takes place as a result of elements from different cultures circulating through or producing a hybrid. In this respect, it's truly appropriate for an exhibition 'with an edge' like this one to be held in Australia, a country of cultural mix and co-existence.

Last but not least, I would like to express my heart-felt gratitude to the Powerhouse Museum for giving the most understanding ear to the KCI's proposals and suggestions. Especially, curator Louise Mitchell's generosity and enthusiasm deserves my highest admiration.

Akiko Fukai
Director and Chief Curator, The Kyoto Costume Institute

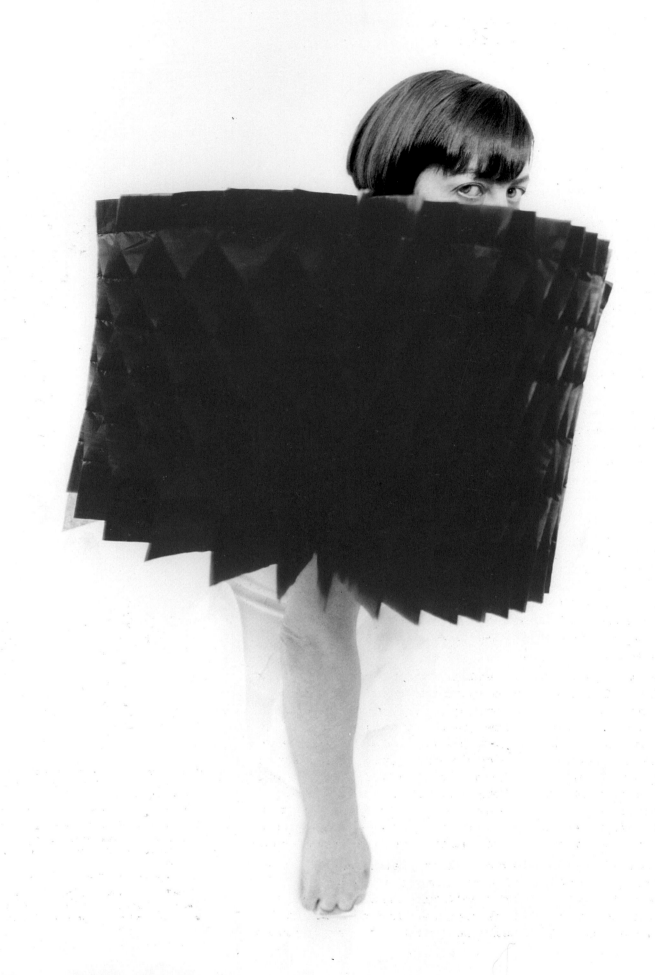

INTRODUCTION

Louise Mitchell

Radical and conceptual, challenging and uncompromising, functional and sometimes incomprehensible, fashion from Japan demands attention. Since the 1970s and 1980s when Issey Miyake, Rei Kawakubo and Yohji Yamamoto established themselves as influential designers in international fashion, Japanese fashion has been acclaimed for its ability to challenge fashion conventions, embrace technology and to point the way forward. *The cutting edge: fashion from Japan* celebrates the skill, experimentation and innovation of Japanese fashion.

The new generation

Of particular interest is the work by a new generation of designers who are little known outside Tokyo fashion and art circles.

Browsing through a flea market in New York while on holiday, Hiroaki Ohya was impressed by a selection of rare books. It seemed to the young designer from Tokyo that unlike fashion with its transitory, cyclical nature, books had a permanency that enabled ideas to be transported over time. Back in Japan, these thoughts led him to create *The Wizard of Jeanz*, a remarkable series of 21 'books' that fold out into clothes.

The Wizard of Jeanz is a technical *tour de force,* a feat of skill that allows a book to transform into a ruffled neckpiece, a pair of jeans or an elegant evening dress. In a similar experimental mood, Shinichiro Arakawa created a series of garments that are framed like paintings but once out of the frame, put on and zipped up around the body become real, wearable clothes. Transformable themes are also seen in Aya Tsukioka's wrap skirt with its apron front screen-printed on the reverse with the image of a vending machine similar to the millions found on Tokyo's streets. When the wearer unties the waistband and lifts the apron above her head, she can 'hide' behind this image. The designer's aim is to provoke laughter by creating clothes that encourage the viewer to recognise the need for moments of respite from the pressures of everyday life.

Kosuke Tsumura questions the role of fashion in today's society with his signature piece for his 'FINAL HOME' label: a transparent nylon coat with up to 40 multifunction zip pockets conceived as a final home in the case of disaster. Tsumura was motivated to rethink his attitude to fashion by the growing number of homeless people living in Tokyo. Expressions of political consciousness and concern for the wider world are also seen in Masahiro Nakagawa's response to Tokyo's overwhelming consumer culture: a recycling project, in which he invites participants to bring him old or unused clothes which he and co-workers from the label '20471120' alter and restructure into new, fashionable garments. Nakagawa's project critiques fashion and consumerism but also seeks to resuscitate a connection between people and their possessions. Similarly, Nozomi Ishiguro's designs, remade and crafted from existing clothes, evoke an emotional response from the wearer.

Some new generation Japanese designers participate in the twice-yearly Paris collections and their designs are acclaimed for their avant-garde quality and use of technically advanced textiles and high level of skill. Junya Watanabe is the most celebrated of the younger generation of Japanese designers and recognised as a major international designer. His collections in the late 1990s were described as 'techno fashion' for their use

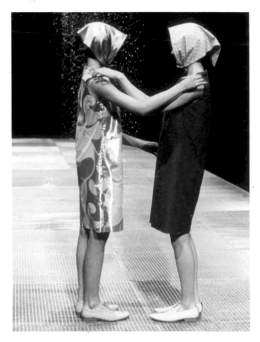

(*Opposite*) Isabella Blow wearing the neckpiece from Hiroaki Ohya's *Wizard of Jeanz*, a series of books that transform into clothing.
PHOTO: NINAGAWA MIKA, COURTESY NINAGAWA MIKA AND VOGUE NIPPON

(*Top*) The spring/summer 2000 Junya Watanabe Comme des Garçons collection was made from a water-resistant microfibre and shown under a manufactured downpour.
PHOTO: JEAN FRANCOIS JOSÉ. COURTESY COMME DES GARÇONS

Kosuke Tsumura's signature piece for the FINAL HOME label is a coat with multifunction pockets. This photo depicts Tsumura trialling a prototype in Shinjuku, Tokyo in 1993.
PHOTO: COURTESY FINAL HOME

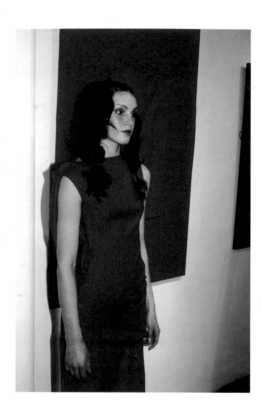

(*Above*) Shinichiro Arakawa presented his autumn/ winter 1999/2000 collection in a Paris gallery. Models were posed in front of the framed outfit. Instructions accompanying the framed clothes read: 'Take the canvas out of the frame. Put your head through the opening and stick your arms through the armholes. Wrap the fabric round your body and do up the zip or buttons. The garment is now ready to wear'.
PHOTO: COURTESY SHINICHIRO ARAKAWA

(*Above right*) The 20471120 team led by Masahiro Nakagawa. The Tokyo Recyle projects which began in 1999, invite participants to bring the design team their old or unused clothes. After a consultation, the clothes are altered and restructured.
PHOTO: AI IWANE, REPRODUCED WITH PERMISSION FROM *NAKAGAWA-SŌCHI 20471120*, JAPAN, 2004

(*Opposite*) Aya Tsukioka's *Instant vending machine* wrap skirts and porthole bag are camouflaged in a Tokyo street scene.
PHOTO: COURTESY AYA TSUKIOKA

of high-tech fabrics such as laminated synthetics in dayglo colours inspired by the gels used for theatre lighting. Naoki Takizawa, the current designer for the Miyake Design Studio (MDS), maintains the experimental reputation of MDS with garments that use advanced fabrics and unconventional tailoring. Yoshiki Hishinuma creates three-dimensional evening dresses combining traditional *shibori* techniques with the technology of thermoplastics.[1] He has recently developed a technique of knitting three-dimensional seamless garments with the aid of a computer-programmed machine.

With the exception of Junya Watanabe, the new generation designers represented in *The cutting edge* are little known in the West. Japan's reputation in international fashion is largely based on the work of Issey Miyake, Rei Kawakubo and Yohji Yamamoto who since the 1980s have maintained their creative dominance by consistently creating fashion that has pointed the way forward.

Miyake, Kawakubo and Yamamoto

The story of Japanese fashion's impact on the West is brief, given that it has only come about in the postwar years. Paris in the early 1980s was already familiar with Japanese designers through the work of Hanae Mori, the first Japanese designer to show abroad (in New York in 1965), the designer known as Kenzo, and Issey Miyake.

Issey Miyake has always had a commitment to innovative design. His current preoccupation, A-POC, is a long tube of fabric that doesn't require sewing and is cut by the customer without wasting any fabric. The photo depicts a catwalk demonstration of the product in 1999.

PHOTO: COURTESY FIRSTVIEW

The interest aroused by their work was not the first time that Japanese design had created an impact on Western fashion. After Japan was opened to the West in the mid 19th century, the European market was flooded with a rich array of Japanese decorative goods. *Japonisme*, which can be defined as the Western assimilation of basic Japanese aesthetics, was influential in not only architecture, painting and the decorative arts in the second half of the 1800s but also in fashion, seen in the use of Japanese motifs and fabric exported from Japan. In the early 1900s the influence was seen not just in the ornamentation but also in the cut of outer garments such as opera coats, created by leading Parisian couturiers, that were reminiscent of kimonos.[2]

But it was the impact of Rei Kawakubo and Yohji Yamamoto's catwalk shows presented in Paris in the first half of the 1980s that really created an intense awareness of Japanese fashion. Kawakubo and Yamamoto's garments were characterised by intentional flaws, a monochrome palette, exaggerated proportions, drapery, asymmetry and gender-neutral styling.

The clothes and models looked shabby, in stark contrast to the power suits and fantasy evening dresses, paraded on immaculately groomed models, in vogue at the time. Although the clothes by these two designers were just as new looking for the Japanese, it has been argued that the aesthetics of traditional Japanese culture (as Akiko Fukai explains in her essay), particularly of *wabi-sabi* (beauty that is imperfect, impermanent or incomplete) and of the kimono, were inherent within their work.[3] Initially the response to these designs was hostile and derisory but within a few years the new aesthetic came to have a major influence on mainstream fashion. 'Japanese fashion in the eighties provided a new way of looking at fabric, texture, cut and image. It questioned the artifice of tailoring and couture, literally deconstructing garments,' recalled art critic Deyan Sudjic. 'Japan in the eighties was a shot in the arm of fashion, a revelation that it could be more than sex, show business and commerce.'[4]

In their different ways, Miyake, Kawakubo and Yamamoto have all created garments that can be appreciated as part of a cultural climate that includes art, architecture and design (as described in Bonnie English's essay). Ideas and themes removed from trends, and fashion in the street sense, have continued to evolve for Miyake, Kawakubo and Yamamoto.

From his time as a graphic design student at Tama Art University in Tokyo during the early 1960s, Issey Miyake has experimented with clothing production. His student show of 1963, titled *A poem of cloth and stone*, aimed to show clothes as both visual creations as well as purely utilitarian items:

> We want to stimulate the imagination through clothing. It is not a fashion show, though the works do breathe in contemporary style. Accordingly, I think the next step will be clothing that looks to the future.[5]

After a period spent in Paris, London and New York working for different couturiers, Miyake returned to Tokyo and set up the Miyake Design Studio in 1970 with textile designer Mikiko Minagawa. Along with his interest in utilising aspects of Japanese folk culture and traditional textiles, Miyake's preoccupation during the 1970s was the development of a garment that was reduced to its simplest elements. Drawing on the tradition of the kimono he produced garments he called 'a piece of cloth', which were, essentially, rectangular in shape with sleeves attached, garments that could be wrapped and draped around the body.

Over the years, Miyake has collaborated with weavers, artists and poets, choreographers and photographers as part of his exploration of what clothes can do and be made from. In the mid 1980s he staged a series of exhibitions aimed at exploring the relationship between the body's form and the garment. Entitled *Bodyworks*, the exhibition contained installations of moulded plastic bustiers (a corset-like garment) with sci-fi connotations, and rattan and bamboo bustiers reminiscent of samurai armour. While these sculptural creations were more at home in a museum or art gallery, Miyake's innovative pleated clothes, developed in the 1990s, have realised his aim of creating practical, modern clothes that are beyond trends. Similarly, his current preoccupation with 'A-POC' (acronym for 'a piece of clothing'), a long tube of stretch fabric that doesn't require any sewing and is cut by the customer without wasting any material, shows an ongoing commitment to innovative design.

Rei Kawakubo studied the history of aesthetics at Keio University, Tokyo, and worked in advertising and as a stylist for fashion shoots before establishing her own clothing label, 'Comme des Garçons' (Like some boys), in 1973. The label was commercially successful in Japan before she teamed up with Yohji Yamamoto to present her controversial collections in Paris in the early 1980s. Kawakubo's oft-quoted remark, 'I work with three shades of black',[6] belies the fact that since the mid 1980s she has departed from her original sombre palette and her collections throughout the 1990s and early this century have often incorporated bright colours. Over the years her clothes have ranged from sombre, asymmetrical and loose fitting to colourful, light hearted, romantic and structured. While her designs have changed a lot and her collections are unpredictable, in Kawakubo's attempts to defy conventional beauty her clothes are still inclined to offend Western assumptions of taste and tradition. Her stated aim is to avoid conformity and to do something new for each collection. She has been cited as the progenitor of a radical fashion movement.[7]

A Comme des Garçons suit may be deconstructed, with its seams unpicked and exposed, threads trailing, its fastenings misaligned or missing. One sleeve of a suit jacket may be cut away and reappear on a matching skirt. Assumptions about sexuality and body image have been challenged in clothes with goosedown-padded lumps that deviate from the female anatomical form. Daring and unexpected combinations of textures, colours and patterns are hallmarks of Kawakubo's clothes, along with a skilful manipulation of fabric. In many of her collections, Western fashion is a reference point for playful reinterpretations of familiar types of garments. Her most recent collection, entitled 'The broken bride', featured bridal gowns:

> ... romantic, Victorian-flavoured creations of lace and ruffle. Each model wore
> an antique lace veil, trailing to the ground, surmounted by ever more colourful
> and evocative circlets of flowers as the procession went on. Their faces were
> powdered white and traced with sequins around the eyes. Their outfits formed
> a poetic sequence: leg-of-mutton sleeves, amazing patchworks of fan pleating,
> tulle, satin, and daisy chains of pure white lace.[8]

Yohji Yamamoto shared a parallel vision with Kawakubo in the first half of the 1980s, the years they introduced their labels together in Paris. The son of a seamstress, Yamamoto completed a law degree at Keio University before switching to study fashion at the Bunka College of Fashion and working for his mother before setting up as designer in

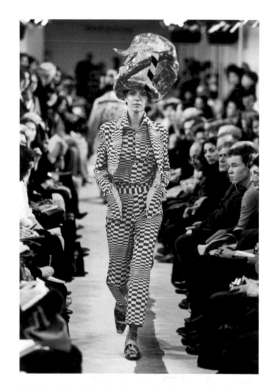

Rei Kawakubo's designs have changed considerably since the early 1980s and her aim with each collection is to present something completely different from the previous collection. For spring/summer 2001, Kawakubo played with visual illusions with fabrics printed with brightly coloured optical and military camouflage patterns.

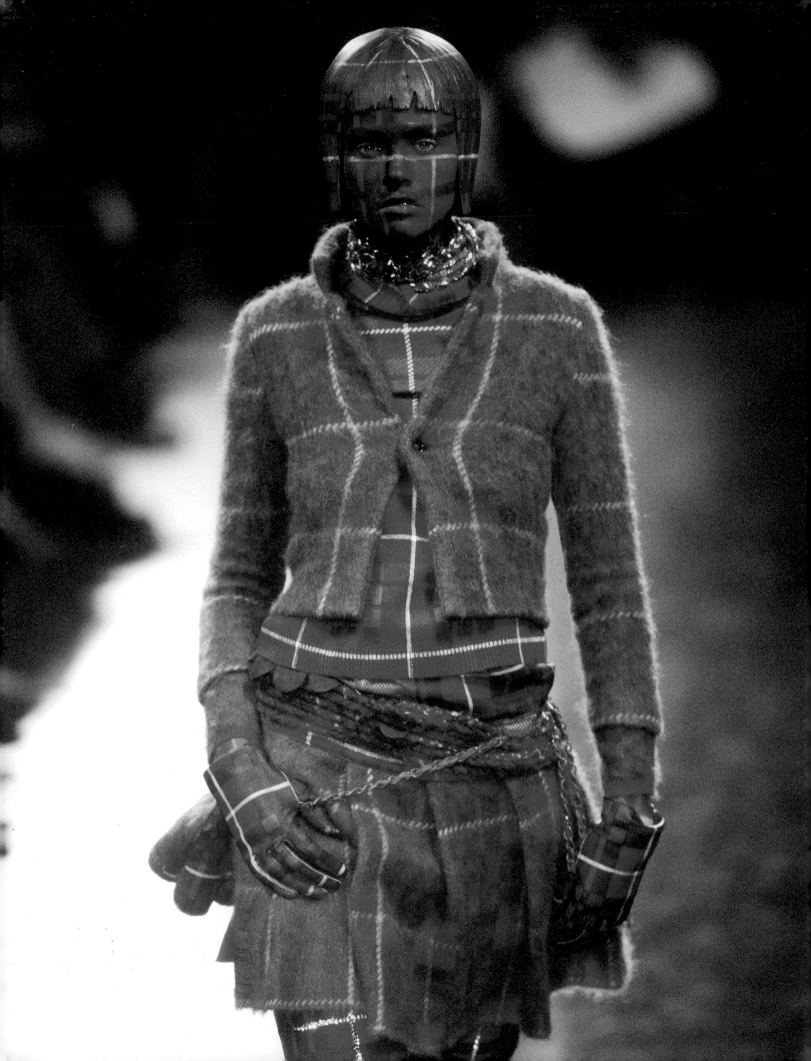

the late 1960s. Since parting ways with Kawakubo, Yamamoto's collections have been characterised by a romanticism more in tune with Western aesthetics.

Yamamoto is renowned for working mostly with black and white. His clothes often have a sculptural quality and he likes to combine unusual materials with a recognisable silhouette— for example, an evening dress made from a felt similar to that used for billiard tables. His clothes are marked by historical references and a sense of renewal, seen in his blending of culture and history. The themes that have inspired his collections over the past 20 years range from Edwardian dandyism to Paris couture and Eastern European folk costume, along with clothing incorporating traditional Japanese dye-resist textile techniques such as *shibori* and *yuzen*, seen in his 1995 spring/summer collection. In 2000 he collaborated with sports label 'Adidas' to create clothes that have been described as a marriage of engineering and fashion.[9]

Now in their sixties, Miyake, Kawakubo and Yamamoto are based in Tokyo where they head large, commercially successful companies that produce clothing lines for the local market, as well as participating in Paris at the twice-yearly pret-a-porter collections. Their creative dominance remains unchallenged. Emerging new designers have often begun their careers working for these three main fashion houses. Junya Watanabe and Jun Takahashi, for example, have been protégés of Kawakubo, while Kosuke Tsumura and Hiroaki Ohya have developed their own labels within the Miyake group of companies.

Although the three major designers see themselves as internationalists and are dismissive of any categorisation of their work based on shared ethnicity, they have individually and collectively had a significant influence on contemporary fashion worldwide. They share the pursuit of avant-garde design, and working practices that demonstrate a close collaboration with the Japanese textile industry.

Creating an edge: the influence and impact of a textile tradition

Japanese fashion designers are inclined to be textile orientated and usually work closely with textile specialists.[10] This is a collaboration not often seen in the West, where even in haute couture, textiles are sourced from industry shows. Japanese fashion designers generally create their own textiles or employ a textile specialist who works with them to realise their visions. It is common practice for the leading fashion houses to control the entire process of developing a new fabric from beginning to end.

Japan has had a rich textile tradition for centuries, and has long been a leader in cotton and silk production. In the transition to a modern, mechanised economy, textiles were one of the first crafts to be industrialised. By the end of the 1800s, the production of textiles was one of the largest industries in Japan. During the 20th century, many of the factories that formerly made kimonos and other traditional garments were able to successfully convert to the production of Western style fabrics.

Rich traditions of spinning, dyeing and weaving, and of patterning methods, embroidery, manipulating, shaping and finishing fabrics have continued in the industrialised context. Many small factories that have converted now specialise in one particular area of technique, being known, for example, for chemical etching or pleating or flocking. The main textile

(*Opposite*) Catwalk presentation of 'Melting Pot' autumn/winter 2000/01 Undercover collection. Detail, layering and eclectic use of colour and pattern characterise Jun Takahashi's Undercover label. The label was introduced in Paris in 2002 under the aegis of Rei Kawakubo.

PHOTO: COURTESY UNDERCOVER

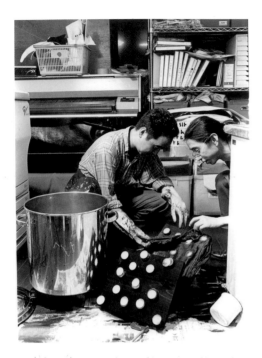

Yoshiki Hishinuma working with his textile designer.
A close involvement with the textile industry gives
Japanese designers a distinctive and innovative edge.

PHOTO: COURTESY OF YOSHIKI HISHINUMA

centres are in the Kiryu, Fukui and Kyoto regions, but textile artisans can be found throughout the country. Alongside the modern large, powerful textile companies such as Toray Industries and Teijin, there still exists a network of smaller factories and artisans who continue to create textiles in time-honoured ways, making it feasible for a fashion house to seek out specialist skills and commission different techniques.

That Japanese fashion was able to flourish as a relative latecomer to the world of fashion was largely made possible by the textile manufacturing system now in place which produces an astounding variety of fabrics. Japan now leads the world in the production of technologically advanced textiles. Major manufacturers invest in the development of new textiles and maintain a flexibility that allows for customised production. Experimenting with different fibres and construction techniques is actively encouraged, similar to the situation in postwar Italy in the 1950s and 1960s, when the close collaboration between manufacturers and designers led to original furniture and product forms.[11]

Experimentation with polyester has been particularly significant for the development of industrially produced textiles and their application in fashion. It was the discovery of a lightweight, easy-care, stretch polyester fabric which could be permanently pleated and accommodate any body movement that was the catalyst for the acclaimed 'Pleats Please' range, created by Issey Miyake and textile designer Mikiko Minagawa. Polyester is a thermoplastic. Its molecular structure breaks down and becomes fluid at a certain temperature, making it possible to reshape the fabric. The application of traditional *shibori* techniques to thermosetting polyester is fertile ground for innovation. With polyester, heat is used in place of dye to set the shaped pattern. Folds, pleats and crumpled textures are indelibly 'baked' into the polyester through a variety of manipulative techniques developed from ancient Japanese textile traditions.

The application of *shibori* techniques can give two-dimensional fabric a three-dimensional form. Yoshiki Hishinuma creates his diaphanous 'extension' evening gowns by securing a handmade propeller-like wooden mould to the polyester before it undergoes heat treatment (see p 49). The 'memory' of the wooden mould remains imprinted in the fabric. A dress created from such fabric with minimal sewing is three-dimensional, with extensions that seem to 'float' from the wearer's body. Using this fabric, Hishinuma was inspired to create a futuristic dress reminiscent of European fashion of the 1700s, whose extensions recall the panniers worn at the hips to achieve the fashionable silhouette of the time.

Textile designers play an important role in creating textiles that can be industrially produced for practical application in interiors and fashion. Designers like Junichi Arai, and Reiko Sudo of NUNO Corporation, create an astonishing variety of textiles with variegated textures, finishes and visual effects. Shrinking, burning, blistering, flocking, chemical etching and dissolving are some of the techniques used to enliven textiles that may combine unorthodox elements such as paper, copper, stainless steel and banana skin with the more traditional wool, cotton, silk, rayon or polyester. A characteristic of these designers' textiles is the interjection of manual processes into manufacturing. As Sudo explains, 'I take fabrics that, in the past, could only be produced by hand and reinvent

them in contemporary ways. I am always exploring industrial means to create things that are seen as traditional, in order to give them a new lease on life in the present.'[12]

The use of technologically advanced fabrics, highly developed skills and ingenuity, and an interest in experimentation and innovation are the hallmarks of fashion from Japan. Japanese fashion avoids seasonal trends and transcends the ephemeral and cyclical nature of the world of fashion. While there are marked differences between the characteristics of individual works, Japanese fashion designers are united in their ability to create new and interesting clothes that have a lasting presence. *The cutting edge: fashion from Japan* celebrates their distinctive vision.

Japanese textile designers create fabrics with a wide range of textures, finishes and visual effects that are industrially produced for practical application. This synthetic textile, designed by Reiko Sudo, is manufactured by NUNO Corporation, a company renowned for its ability to blend tradition and innovation in textile production.

PHOTO: COURTESY NUNO CORPORATION

NOTES

1. *Shibori* is a Japanese term for the process of manipulating and securing particular areas of fabric before dyeing.

2. Japonisme first took hold in Paris in the 1850s and 1860s among the avant-garde painters of the day. The vogue for Japanese wares was influenced by merchants like Arthur Liberty but also designers such as Christopher Dresser and EW Godwin. Japonisme in architecture, painting and the decorative arts has been well documented, but it wasn't until the 1990s that the Kyoto Costume Institute presented a series of exhibitions which demonstrated the influence and the assimilation of basic Japanese aesthetics in Western fashion.

3. In 1985 Harold Koda, in 'Rei Kawakubo and the aesthetics of poverty' (*Dress: Journal of the Costume Society of America*, vol 11, 1985, pp 5–10), proposed Kawakubo's early work in the context of Zen philosophy and *wabi-sabi* aesthetics. More recently Patricia Mears in 'Etre japonais: une question d'identité' (*XXIème ciel mode in Japan*, 5 Continents Editions, Milan, 2003, pp 65–99) has argued that Kawakubo and Yamamoto's early works have been influenced by the contemporary distillation of traditional aesthetics. Kawakubo herself denies the influence of *wabi-sabi* in her work. See interview with Dorinne Kondo in *About face: performing race in fashion and theater* (Routledge, New York, 1997).

4. Deyan Sudjic, 'Japan style', in Maria Luisa Frisa and Stefano Tonchi (eds), *Excess: fashion and the underground in the 80s*, Edizioni Charta, Milan, 2004.

5. Issey Miyake, *Making things*, Scalo, Paris and New York, 1998, p 150.

6. Quoted in Caroline Evans and Minna Thornton, *Women and fashion: a new look*, Quartet Books, London, 1989, p 163.

7. Christopher Breward, 'Fashion', in *Oxford history of art*, Oxford University Press, 2003, p 229.

8. Sarah Mower, review of Comme des Garçons Fall 2005 ready-to-wear collection, Style.com/fashionshows/ collections/F2005RTW/review/commedesgarcons

9. Claire Wilcox, *Radical fashion*, Victoria and Albert Museum, London, 2001, p 2.

10. Yoshiko Iwamoto Wada, *Memory on cloth: shibori now*, Kodansha, Tokyo, 2002. Much of the information about the Japanese textile industry was found in this book, particularly concerning *shibori* and Hishinuma.

11. Cara McCarty, *Structure and surface: contemporary Japanese textiles*, The Museum of Modern Art, New York, 1998, p 12.

12. Quoted in Yoshiko Iwamoto Wada, op cit, p 60.

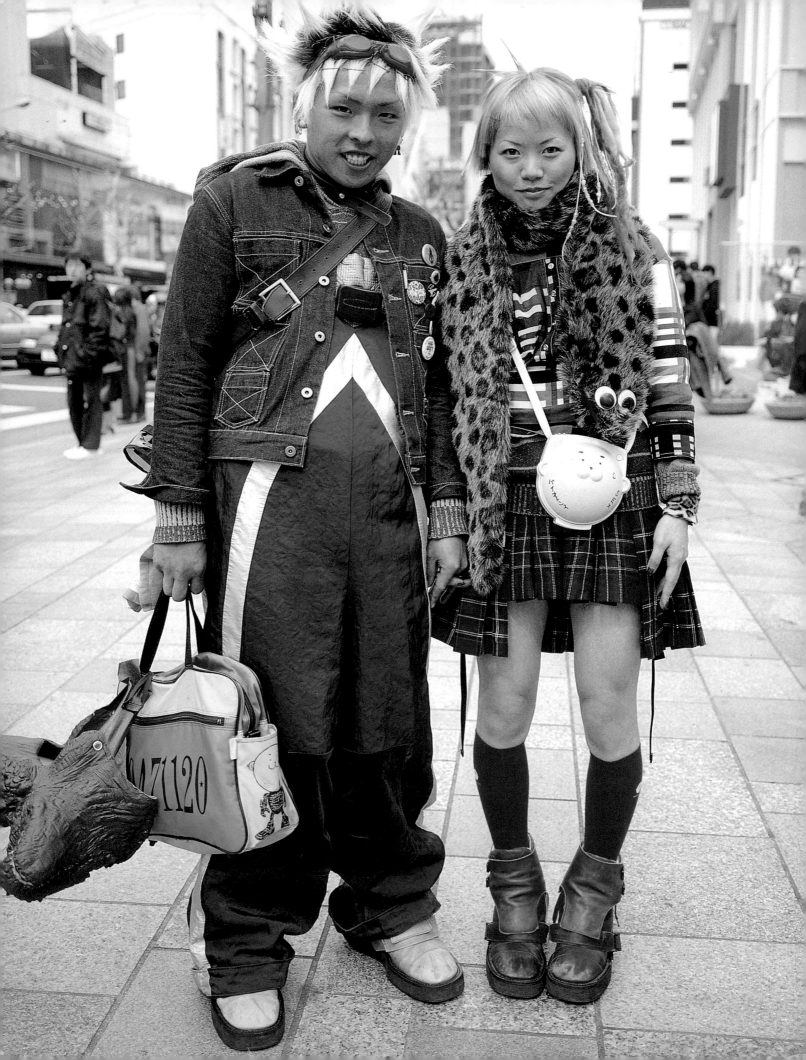

A NEW DESIGN AESTHETIC

Akiko Fukai, Director/Chief curator, Kyoto Costume Institute

In 2005, it is still uncertain where the new century is heading. Will the internet render culture and fashion more uniform around the world or strengthen regional differences? What is clear at this moment is that the contemporary culture of Japan is drawing international interest. All over the world, sushi restaurants, for example, are highly popular, *anime* and *manga* (Japanese animations and comics) are captivating young people and a new generation of Japanese artists is achieving remarkable successes.

In a phenomenon that began in the late 20th century, Japanese taste is attracting the world's enthusiastic attention, rather as it did towards the end of the 19th century when *Japonisme* had a profound influence on the West, in fields from fine arts to the lifestyle arts and fashion. It's not wrong to say that current interest was initially stimulated by modern Japanese fashion design, which has become a synonym for creativity and now occupies an important position in the world fashion scene.

While the country's astonishing economic growth of the 1980s has greatly slowed, we should remember that Japan gained increasing recognition in art and culture in the same decade. The world rediscovered aspects of Japanese culture in the works presented by a number of important artists, particularly in graphic design, architecture and fashion design. Japanese design removed decoration instead of adding it, and discarded colour in favour of black and monochrome shades. This asceticism, seen as an expression of the traditional aesthetic of *wabi sabi*, led the 1980s trend to minimalism. Fashion generated the strongest impact. Since then, it's been unthinkable to discuss fashion without consideration of 'Japanese power', even in Paris.

Although from a country regarded as a latecomer to the world of fashion design, designers like Issey Miyake, Rei Kawakubo and Yohji Yamamoto spearheaded innovation in late 20th century fashion. Those in the following generation, including Junya Watanabe, also were recognised internationally and won high acclaim. If this came about because of some unique characteristics presented by these designers, what were they?

After centuries of isolation, Japan opened its doors to the rest of the world in the mid 19th century, and to the influence of Western ideas. Western clothing steadily gained ground amongst Japanese men but it wasn't until after the end of World War II that many Japanese women began to dress in Western style. Over the next few years more and more women replaced traditional attire with Western dress. Fashion news from Paris began reaching Japan, although with some delay, and was welcomed. By the 1960s, the newly emerging apparel industry was growing rapidly.

An increasing number of young people aspired to design fashion. Amongst them was Kenzo Takada, who went to Paris in the 1960s and became highly sought after in the 1970s. His success coincided with the student-led, so-called 'May Revolution' of 1968, which rocked traditional French values. The old-established haute couture industry was being overpowered by the new force of pret-a-porter when Takada's creations, in which he skilfully blended Japanese colours, designs and styles with Parisian tastes, were accepted. Although he is undeniably Japanese, Takada is a Paris designer in the sense that it was Paris that nurtured him. Then in 1974, Issey Miyake showed a collection titled

Japanese high school girls wearing Western-style dresses in a street in Tokyo in 1937.

PHOTO: COURTESY APL/CORBIS

(*Opposite*) High school students from Nagoya, Suguru and Kaori, dressed in 20471120. They were photographed in Harajuku Tokyo in 2000 by Shoichi Aoki for his *Fruits* magazine, in which he documented Tokyo's fashion subcultures.

PHOTO: SHOICHI AOKI, COURTESY SHOICHI AOKI

'A piece of cloth' in Paris. He based his very simple designs on the underlying concept of the traditional Japanese garment the kimono, its two-dimensionality. 'A piece of cloth' formed the springboard of Miyake's dressmaking and would remain the main pillar of his creative principles as he became recognised all over the world.

1980s: 'Japanese power' with Rei Kawakubo and Yohji Yamamoto

'Paris looks Japanese' was one of the many newspaper headlines referring to the 1982 autumn/winter season in Paris. With the word 'Japan' scattered all through them, the articles reported in shocked tones on the designs of the then unknown Rei Kawakubo and Yohji Yamamoto, who had launched their careers in Paris only one year earlier. Who knew at the time this was the beginning of the wave of Japanese fashion that would rock the world?

Kawakubo and Yamamoto were already successful in Japan when they decided in April 1981 to present collections in Paris in that year's autumn/winter season. A year later, almost every major newspaper in Europe and the United States allocated a large proportion of their fashion pages to the Japanese designers. In the 1983 spring/summer season, Kawakubo and Yamamoto made their pale-faced, no-make-up models walk the catwalk brusquely, with stern expressions. Their dark-coloured, enigmatic dresses defied human body shape and looked as if they'd been 'shredded in a bomb attack'. French newspaper *Le Figaro*, with its leanings toward the establishment, and hence toward haute couture, unashamedly expressed its discomfort by calling the designs 'yellow perils', and declaring them to be 'WW3 survivors' looks' and 'rags'.[1] The *Washington Post* in its article, on the other hand, carried a large photo of Yohji Yamamoto's much-holed white dress, which the writer named a 'Swiss cheese dress', with a quote from *Vogue*'s Polly Melon. She said: 'It's modern and free. It has given my eyes something new and has made this first day [of the Paris collections] incredible. Yamamoto and Kawakubo are showing the way to a whole new way of beauty.'[2] French journal *Libération* said: 'Kawakubo gave patches and darns a definite value from fashion and culture.'[3] Although reviews were mixed, it was no longer possible for those against their designs or, needless to say, those who supported them, to ignore the work of Kawakubo and Yamamoto. They caused an enormous sensation because nobody had ever seen designs like theirs, in such stark antithesis to conventional Western fashion.

Japanese aesthetics

The clothes may have looked like rags but the holes were intentional. And while clothing which looked like a rag with extra pieces of cloth hanging off it challenged Western notions of decoration, this could nonetheless be regarded as decoration from a different aesthetic sensibility. The Japanese designers' viewpoint was that pauperism was the ultimate result of extravagance. The stark lack of colour could be compared with the monochromatic tones of *sumie* (traditional Japanese ink drawings). Kawakubo and Yamamoto patently ignored the beauty that Western clothing had been long pursuing. Their shocking images, approving shabbiness, rocked the very foundations of the Western concept of fashion. Today it's not uncommon to find the pauper look, but in the early 1980s in Paris not many people saw it as desirable.

In fact, many people were so upset that they didn't even try to hide their dismay. Behind their emotion was astonishment at such audacity, and a cultural divide in the conception

(*Opposite*) Kawakubo's Comme des Garçons black torn knit, photo by Peter Lindbergh 1982.

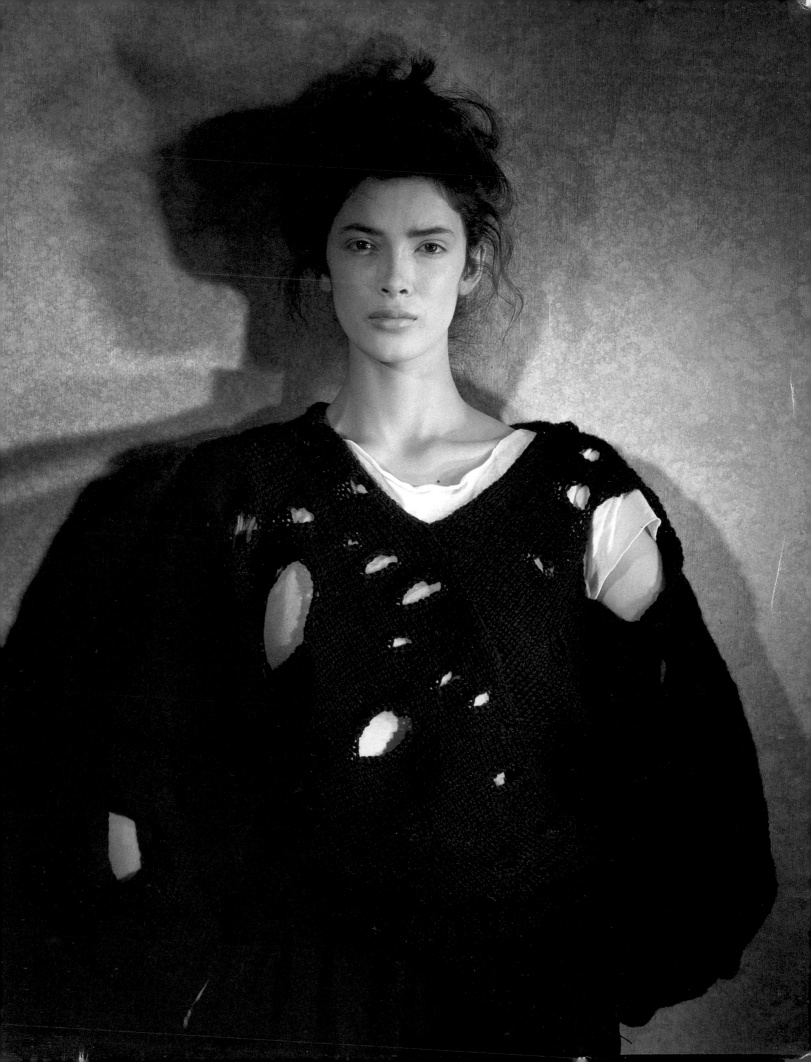

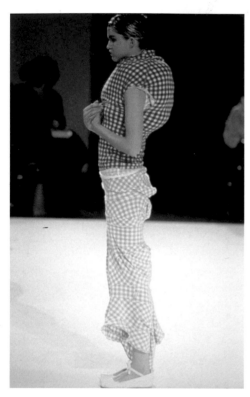

Comme des Garçons gingham 'Quasimodo' dress in the spring/summer 1997 show in Paris.

PHOTO: JEAN FRANÇOIS JOSÉ, COURTESY COMME DES GARÇONS

of clothing. Western dressmaking took the natural shape of the human body as a given, and its objective was to produce a solution to the challenge of contouring a three-dimensional form using two-dimensional fabric. By contrast, Japanese designers' creations shrouded the body. They concealed the curvaceous bosom, the narrow waist, the natural proportions of the female shape. It's probably not wrong to assume (whether this is good or bad) that deep in the mind of every Japanese person lies the culture of kimono. In that culture, the fabric is put on the human body in a manner that acknowledges the fabric's two-dimensional nature. This results in an excess of fabric that creates drapes. Japanese see this excess as *ma* (meaning 'space') and never consider it illegitimate. The Japanese designers' baggy, shapeless dresses were in many cases also asymmetric, another of the elements of Japanese aesthetics. Their designs also demonstrated a universal approach to clothing, breaking down the barriers of gender, age or body shape just as a kimono does.

The Japanese fashion designs were in a sense an embodiment of the aesthetic of *wabi sabi*, and also offered a sense of breaking completely free of the past. Although this was yet beyond their understanding, Westerners somehow began to perceive a fresh sense of beauty. Traditional Western clothing had never been challenged in its dominance of world style when Kawakubo and Yamamoto created a shock-wave of surprise with ideas and expressions derived from a completely different cultural context. Their creations were clear-cut proof that clothes could be inspired by ideas other than Western concepts. Nor was this just a fleeting notion—it served as a precursor for fashion to make its way forward into the 21st century.

By the mid 1980s, fashionable dress shops in Paris, New York and London had begun to look much like boutiques in Tokyo, with black, baggy garments folded flat on grey metal shelving in a breakaway from the norm that saw clothes hung on racks. Japanese fashion had secured a definite and significant position. Before long, elements such as hang-outs, rags, rips, monochromatic black and asymmetry would win a faithful following amongst young designers—like Martin Margiela from Belgium, a country then seen as marginal by Paris fashion standards, but now recognised worldwide.

Fashion drives itself relentlessly through the cycle of the seasons. With her insight into the nature of fashion, Kawakubo even moves ahead of it, offering an innovative proposition every single season. In the late 1980s, she transformed her showings with her mastery of colour. In one season she approached street fashion with her neo-Punk designs; in the next, she boldly applied the plastic arts to the expression of her aesthetic. Kawakubo never pursues what is familiar, what is defined by the Western tradition as beautiful. Nor does she seek to demonstrate femininity or any other long-held stereotypic image of fashion or women. She never ceases to create definitive garments that no one has ever seen before. Kawakubo will remain an inspiration to young designers for generations.

Of all her creations, Kawakubo's 1997 series of 'Quasimodo dresses' best sums up her design aesthetic. The double-layered stretch nylon creations have a number of pads on the back, shoulders, abdomen and hips filled with feather and down and forming curious lumps and bumps. The clothes act like two layers of skin that blur the boundary between body and garment, fusing them into one. When the wearer moves, body and garment

together create intriguing, unpredictable shapes. How much does the series inspire viewers' imagination? It prompted American choreographer Merce Cunningham to create the fascinating new dance work *Scenario*.[4] In this work, male and female performers dance in costumes created by Kawakubo which obscure gender differences.

Kawakubo's designs may appear to lack continuity from season to season but there's at least one constant, which is her unique sense of the contemporary. Once I asked the young Dutch designers Viktor & Rolf who intrigued them. They named Kawakubo without a hint of hesitation. They undoubtedly hold an abiding respect for this relentless seeker of innovation.

After his phase of deconstructionism in the mid 1980s, Yohji Yamamoto inclined more towards tailored designs and dressmaking that used a full range of splendid couture techniques, more in tune with the Western dressmaking he was associated with in his early career. Nonetheless, his designs still featured Japanese aesthetic elements such as asymmetry and the colour black. Yamamoto called black 'an intelligent modern colour'. Many other designers moved to the use of black in the 1980s—it became the flavour of the time in fashion and elsewhere, and remained so almost through to the end of the 1990s. Black represented asceticism in an age of abundance. With his eyes firmly fixed on modern society, Yamamoto never deviates far from the contexts of Western culture, which makes him one of the Japanese designers best understood in the West.

Since 2001, Yamamoto has teamed up with the popular global brand Adidas, first in sports shoes, followed by the sportswear-cum-attractive-street-clothes label 'Y-3'. In 2002, he carried out a restructuring of his business, placing his best-known label, 'Yohji Yamamoto', in status almost as high as haute couture, in Europe and the United States, and giving another of his labels, 'Y's', a pret-a-porter line. One of the main reasons behind the strength of the Paris fashion industry is its complex, multi-layered structure topped by the luxury haute couture section. It will be interesting to see if and how Yamamoto's strategy of diversity brings that sort of strength to Japanese fashion.

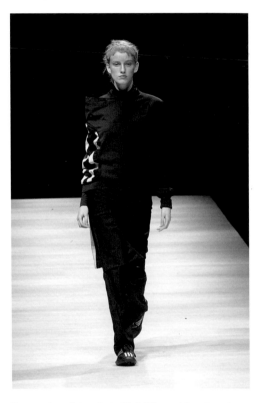

Yamamoto collaborated with Adidas on his autumn/ winter 2001/02 collection.
PHOTO: COURTESY FIRSTVIEW

Crinkles, holes and frays: a review of tattered drapes

It is worth revisiting the crinkles, holes and fraying edges of Kawakubo and Yamamoto's designs of the 1980s. German philosopher GWF Hegel once said, 'Our skin is a kind of covering which testifies to the imperfection of nature.'[5] Western aesthetics have held the view that clothing is to mask that imperfection. As clothes, or drapes, to use another word, are to hide the imperfections of the body, they must not have 'the slightest flaw of overlap, crinkle or crease'.[6] It's possible to say that Western fashion, not unlike art, has long devoted itself to creating a beautiful, perfect skin in the form of drapes.

There have been some attempts to defy this aesthetic. Artist Lucio Fontana (1899–1968) ripped his canvases with a knife. In the 15th and 16th centuries, clothing with *crevés* (slashes) was popular.[7] In the late 1970s, the young Londoners known as Punks displayed their opposition to the accepted Western concept of beauty, asserting themselves in forms extremely easy to understand—torn jeans, countless safety pins and studs attached to the fabrics and their persons.

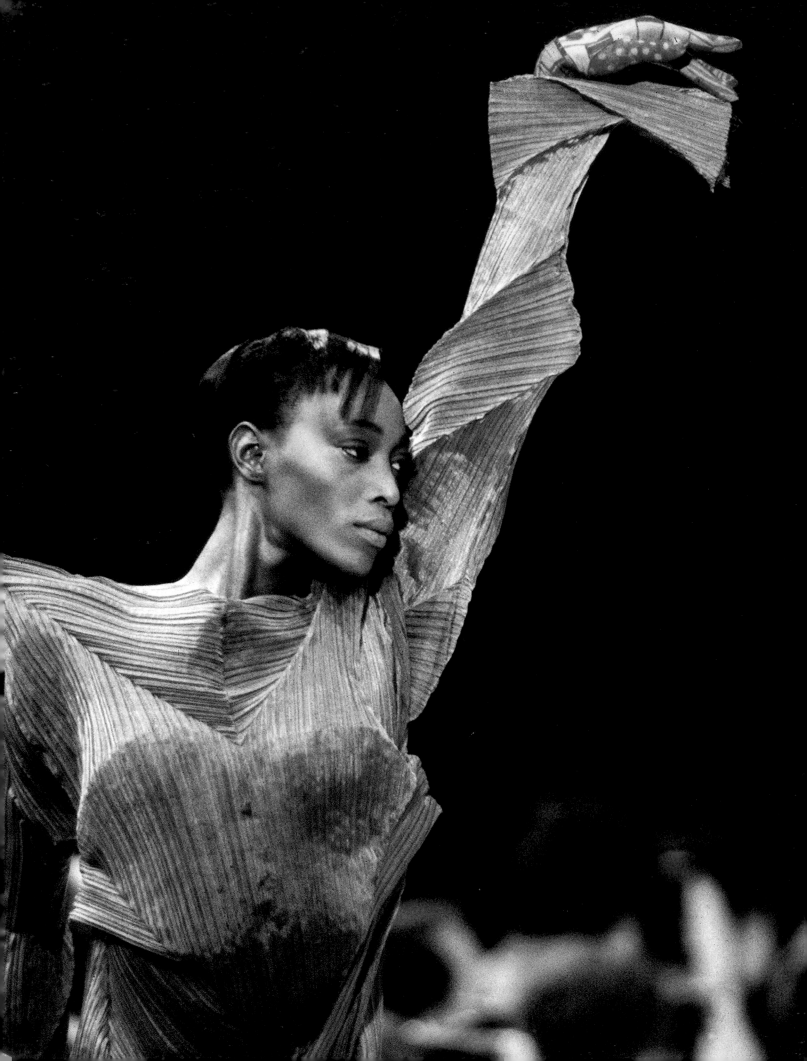

From the early 1980s, Kawakubo and Yamamoto presented works derived from their individual concepts of the beauty of drapes. Their drapes were torn; they had holes. They had tattered pieces, rags, dangling from them for no apparent reason. Their clothes were wrinkled, ripped, twisted and pitiful to look at, simply torn fabric pieces stitched together. In no way did they respect the notion of clothing as something to show off the beautiful body, nor did they respect the concept of clothing or beautiful drapes as something to conceal the imperfect body. In the eyes of many, these designs were 'doomsday fashion'. In the 1990s, however, crinkles, frays, tatters, holes, ripped pieces and inside-outs won the name 'grunge' fashion, and eventually became a familiar everyday sight, not only in street fashion but also in high fashion.

What actually happened was that a great number of wearers rediscovered themselves in clothing that broke all the rules of conventional fashion. Grunge destroyed the conventional image of clothing as something that conceals the imperfect, meagre skin with every possible gorgeous attachment. It redefined clothing. It expanded the possibility of various forms of garments and led fashion into a completely new territory. The role played in these developments by the fashions from Tokyo in the 1980s is self-evident.

1990s: Issey Miyake challenges

In the 1990s, many young Japanese designers headed for the world stage. Junya Watanabe made his debut in Paris in 1992 and his dynamic and flexible pleats and drapes were recognised in Europe and America. Jun Takahashi of Undercover followed.

Issey Miyake was already one of the most acclaimed designers of the second half of the 20th century when he won further recognition with his series of pleat designs. Certainly, pleats were not new to dressmaking but the way Miyake used them turned them into something newly relevant. Usually fabric is pleated before it is cut and sewn together. Miyake reversed the process, cutting out the pattern pieces before he pleated them. This simple reversal of method produced completely new clothes in which material, form and function twine together almost organically. Miyake's pleats were different, even from the delicate designs of Mariano Fortuny in the early 20th century. Miyake's pleated garments were attractive creations firmly rooted in the Japanese dressmaking tradition that regarded the fabric as vitally important, while at the same time they strongly supported the advanced technology of the Japanese textile industry. Lightweight, wrinkle-free and reasonably priced, they met the demands of the modern lifestyle. When he first showed the 'Pleats Please' series, Miyake expressed the hope that his dresses would occupy as indispensable a part of the wearer's life as the baguette does in a French person's life. His wish has definitely come true. After more than ten years, Miyake's garments are worn by people all around the world.

In 1999 Miyake held an exhibition called *Making things* at the Cartier Foundation in Paris, which made a deep impression. As well as his pleat designs, he showed the 'A-POC' range, which he'd been developing since earlier that year, stretch knit tubes with garment patterns woven into them by computer. If you cut along the outline of the pattern, you end up with a garment such as a dress, a shirt, a skirt or a pair of pants. Although computer-produced, they have the simplicity of the knitted garments of earlier days.

(*Opposite*) Issey Miyake's 'Mutant pleats' collection, autumn/winter 1989/90.

A-POC deconstructed the human body into arms, legs and torso, then recomposed these parts into garments. French critic Roland Barthes said, 'We could say in its profane way the garment reflects the old mystical dream of "seamlessness"; since the garment envelops the body, is not the miracle precisely that the body can enter it without leaving a trace of doing so?'[8] An A-POC garment is like a brand-new skin. Once you slip into it, the curves of your body emerge in freshly expressive drapes.

In effect, clothes, or drapes, are skins which we can put on and take off. Before the 20th century, clothes were merely coverings confined by set visual values and recognised only as something that masked imperfection. But even so, of course, clothes were objects to look at. Designers and dressmakers resorted to every visually exciting form they could think of to stimulate tactile sensitivity. In the 20th century, the skin's unequivocal status as the boundary between the inside and the outside of the body came to be questioned. As the casing of the inner being, no less than the body's surface, skin reclaimed a long-lost sense of representing a more complex view of the human body. One of skin's important functions, the sense of touch in particular, won heightened awareness. Fashion also shifted its interest to tactile effects, which added a new approach to the creativity possible with drapery. With these changes, the whole meaning of clothing came under reconsideration. The possibilities inherent in clothing and fashion entered unknown territory.

Kawaii: the Japanese image in the 21st century

Traditional aesthetics undeniably had a place in Japanese fashion of the 1980s. The notion of *wabi sabi*, best symbolised by the simple beauty of a Japanese tea house, was epitomised by the period's monochromatic colour, asymmetry, minimalism, attention to detail despite an austere appearance and, more than anything else, its avant-garde spirit.

At the other end of the scale is popular taste, represented by *ukiyo-e* prints in the Edo era and by *manga* and *anime* today. Since the 1980s, Japanese *anime* programs for children have become familiar in many other countries. People who grew up watching them have become interested in Japanese culture. In *manga* and *anime*, infantilism, comprehensibility, bad taste and vulgarity are mixed together, with populism the common denominator. And no doubt their easy likeableness has enabled their penetration to every corner of the globe.

Manga is closely linked to the idiosyncratic street fashion found in Shibuya and Harajuku. These districts in central Tokyo are the haunts of young girls dressed like infants, to 'look *kawaii*'. In the Kojien dictionary, *kawaii* is defined as the quality of someone young or childlike or something small that evokes in others a desire to treat him/her/it fondly. *Manga* characters and *anime* images, including Astro Boy, Hello Kitty and Robo-kun, have been incorporated in the designer clothes shown in pret-a-porter collections in Paris. The costumes of the leading characters in the *anime* features *Sailor moon* (1995) and *Final fantasy: the spirits within* (2001) have attracted great interest. Their infantilism, bad taste and vulgarity have been winning the hearts of the public in Europe and America and the rest of the world, shared through numerous internet sites.

Designing for Dior, one of Paris' most elegant establishments, Galliano adopted the bad taste accepted amongst the younger generation and in so doing brought the antiquated

Dior image back to life. Louis Vuitton used Takashi Murakami's *manga*-inspired designs, with *kawaii* as their keyword, extensively in the 2003 spring/summer collection and made a great impression. As well as its variety of colours, the collection's infantile character swept the world. The Japanese word *kawaii* is now recognised internationally.

In conclusion: tradition and the avant-garde

The Japanese artists Takashi Murakami and Yoshitomo Nara are sometimes compared with the popular practitioners of the Edo era's *ukiyo-e* art form, the two-dimensionality and deliberate deformation of which impressed painters such as Manet, Monet and Van Gogh during the period of Japonisme in 19th-century France. Present-day Japanese artists base their works on traditional concepts of beauty but add to them something that suits the tastes of today's 'liquid crystal display' generation. In other words, old traditions are alive and well in their very contemporary works.

In the 1980s, Japanese fashion made an impact with its *wabi sabi*-inspired designs in tune with the minimalist movement. In the 21st century, it is attracting renewed attention with its *manga*-inspired *kawaii* designs. This can be seen as a transitional phase, at a time of uncertainty in which the world is exploring innovative styles and designs as it seeks for a new framework of society.

NOTES

1. *Le Figaro*, 21 October 1982.
2. *Washington Post*, 16 October 1982.
3. *La Libération*, 19 October 1982, no 442.
4. Merce Cunningham Dance Company, *Scenario*. Music by Takashi Kosugi. Stage and costume design by Rei Kawakubo. First performed 1997.
5. GWF Hegel, *Vorteungen uber die Asthetik*, translated into Japanese by Hiroshi Hasegawa, Sakuhin-sha, 1996, p 349.
6. Ibid, p 347.
7. A kind of ornamentation in 15th and 16th century European fashion where slashes in an outer layer of fabric showed the fabric beneath.
8. Roland Barthes, *Système de la Mode*, translated into Japanese by Nobuo Sato, Misuzu Shobo, 1972, p 194.

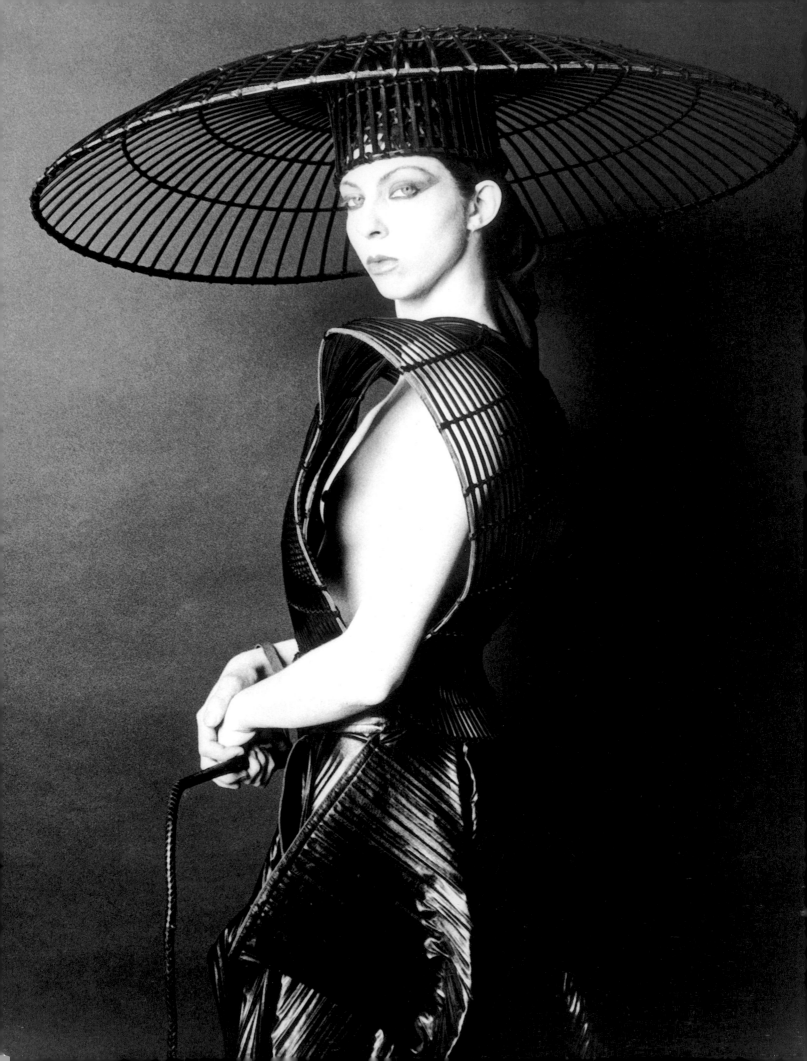

FASHION AS ART
POSTMODERNIST
JAPANESE FASHION

Bonnie English

Since the 1970s, the designs of Issey Miyake and Yohji Yamamoto, and Rei Kawakubo of Comme des Garçons, have had a noticeable impact on Western dress. Offering a new and unique expression of creativity, they have challenged the established notions of status, display and sexuality in contemporary fashion. Ignoring stylistic trends, these Japanese designers work within a postmodernist visual arts framework, appropriating aspects of their traditional culture, and embracing new technological developments and methodologies in textile design. Yet, at the same time, they infuse their work with meaning and memory. They have been applauded by those who look for connections between conceptual art and fashion and feared by those who thought they might change the face of fashion irrevocably … which, of course, they did.

Postmodernist fashion relies on visual paradox—underclothing becomes overclothing, new is replaced by old, and propriety in dress is replaced by a total lack of respect for the display of status and value systems. Highly priced, slashed and torn garments symbolise an economic irrationality, where to 'dress up' is to 'dress down'. A social paradigm is created and a new visual ethic is embraced. The literal deconstruction of fabric seemingly reflects the deconstruction of past values.

Harold Koda, curator of the Costume Institute, Metropolitan Museum of Art, referred to this new concept of dress, as seen in the work of Yamamoto and Kawakubo, as the 'aesthetics of poverty'—a phrase which seemed to aptly describe the new dress code. He compared the 1980s trend with the 1890s, a time which also 'saw decadence as an aesthetic ideal'.[1] In ideological terms, dress design has undoubtedly responded to social, political and economic instabilities throughout history. In the 1970s, 1980s and 1990s, global events such as high unemployment, youth revolutions, anti-war sentiment, global poverty and environmental catastrophes impacted greatly upon the conscience of society and became implicit to postmodernist visual arts practice. While cultural differences existed, both punk fashion and the work of the Japanese designers, Yamamoto and Kawakubo, reflected this practice. Their fashions were characterised by torn, ripped and ragged fabric, uneven and unstitched hemlines—a disarray that was quite calculatedly subversive. Their unprecedented influence saw a new form of anti-fashion emerge as the dominant aesthetic in the early 1980s.

For centuries, Western fashion has doggedly adhered to a structured and tailored fit which extolled the virtues of sexuality, glamour and status—the mainstay of European haute couture. American sociologist and economist Thorstein Veblen, in *The theory of the leisure class*, written in 1899, coined what was to become a well-worn phrase—'conspicuous consumption'.[2] At the time, it was directed at Victorian ostentation in dress, yet this term underlines the key motivational role that the display of wealth in dress has played throughout history. Visual sumptuousness reflected an individual's standing in society, status in the hierarchical order and defined position within a social class system. Veblen both questioned the need for this pecuniary emulation, and argued that the material display of wealth reflected 'status anxiety'. Arguably, the 19th century's strongly held notion of social-class elitism gradually diminished as middle class consumerism blurred the distinctions between the classes through the course of the 20th century.

(*Opposite*) 'Claudia Summers wearing an Issey Miyake outfit', silver gelatin photo by Marcus Leatherdale, 1983.

As history has shown, the growing 'democratisation' of fashion eventually led to a contradiction of modernist ideals and practices. What had defined haute couture fashion—the uniqueness of design, fine finishing techniques, unblemished surfaces, exquisite tailoring and hand sewing—gave way to the dominance of mass-produced ready-to-wear (pret-a-porter) clothing, a new culture of dress that appeared to mock the exclusivity of earlier fashions.

In giving impetus to this change, according to fashion historian Colin McDowell, the Japanese designers, Kawakubo and Yamamoto, 'made few concessions to traditional Western ideals of dress, chic or beauty' and their clothes were 'as much a statement of philosophy as they were of design'.[3] These avant-garde designers produced clothes that appeared radical to Western eyes and could almost be seen as a homage to their country's past and a challenge to the increased Western influence there.[4]

Yamamoto and Kawakubo grew up in postwar Japan. It is important to remember that, during and immediately after World War II, Japan suffered years of austerity and impoverishment which was imprinted on the minds of many. Within this context, their early 1980s collection showings in Paris can be better understood.[5] It could also explain the media reaction to their collection in 1982, when derisory fashion headlines screamed 'Fashion's Pearl Harbor' and Kawakubo was described as a 'rag picker'. Their models, dressed in black deconstructivist clothes, looked cadaverous with either shaved heads or seemingly dirty unkempt hair, and pasty white faces that were 'devoid of make-up, apart from a disturbing bruised blue on their lower lips'.[6] Arguably, the fashion press saw this work as a political statement. And perhaps it was.

To appreciate the economic environment in Japan in the postwar years, let us consider an anecdotal passage in Arthur Golden's *Memoirs of a geisha*. This biography reveals the arduous life of Sayuri, a young geisha who worked in the Gion district in Kyoto just before the war. Sayuri recalls:

> 'In Japan, the years between the Depression and WW2 were referred to as *kuraitani*—the Valley of Darkness, when so many people lived like children whose heads had slipped beneath the waves … By 1940,' she continues, 'things grew worse and worse around us during the course of several years after the rationing of goods had begun … We had so little charcoal that we burned compressed leaves for warmth and of course the food had grown still more scarce. We learned to eat soybean dregs, usually given to livestock and a hideous thing made from frying rice bran in wheat flour. When a famous kimono maker in Kyoto called Arachino heard his grandson crying from hunger, he would sell one of his prized kimonos from his collection. That is what we Japanese called the "onion life"—peeling away a layer at a time and crying all the while.' … Sayuri goes on to say, 'The war ended for us in August of 1945. Anyone who lived in Japan during this time will tell you that it was the bleakest moment in a long night of darkness. Our country wasn't simply defeated, it was destroyed—and I don't mean by the bombs, as horrible as they were … During the period of a year or more, I never once heard the sound of laughter. I've often observed that men and women who were young children during those years have a certain seriousness about them; there was little laughter in their childhoods.'[7]

(*Opposite*) With its ragged look created by patchwork of knitted wool pieces twisted and stitched together, this dress typifies the new aesthetic introduced by Rei Kawakubo. Photo by Peter Lindbergh of Claudia, Comme des Garçons autumn/winter 1984/85.

PHOTO: © PETER LINDBERGH, PARIS, FRANCE, 1984, COURTESY MICHELE FILOMENO FRANCE SARL

Yamamoto has been described as a designer who is driven by an existentialist philosophy and whose work elicits an intellectualism that ties form with meaning and memory. In his autobiography *Talking to myself,* he asserts that 'dirty, stained, withered, broken things seem beautiful to me'.[8] The Japanese term *hifu* (an old term from No theatre) refers to a form of anti-style, and is seen as an undeniable element of Yamamoto's dressmaking. According to Yamamoto, one can actually 'feel' *hifu* clothing—its confusion, shabbiness and disarray—as if it reflects a meagreness of spirit or sadness in the people wearing the clothes. In other words, the disarray of the fabric mimics the emotional fragility of the wearer. This merging of the emotional, intellectual and aesthetic encouraged many viewers to see his collection showings as a form of performance art.

He describes his work as being 'contradictory' to the commercialism of Western fashion. He creates clothing that has a universal appeal, a timeless quality—clothes that are meant to last a lifetime. In the 1980s he was greatly inspired by the photographs of August Sander, taken during the 1930s Depression years in the American mid-West. The images of farm workers ploughing the dusty fields in faded and tattered work clothes, of women and children huddling in shanty doorways, elicit an honourable dignity that he tried to emulate in his own collections. Yamamoto has observed:

> I like old clothes; clothes are like old friends … What makes a coat truly beautiful is that you're so cold you can't live without it. It's like a friend or member of the family. And I'm terribly envious of that.[9]

By placing Yamamoto's work within the framework of postmodernist visual arts practice in the 1980s and 1990s, it is difficult not to consider the work of other contemporaneous artists such as France's Annette Messager and Christian Boltanski, and a number of the post-feminist artists, who used clothing as a means of eliciting an emotive response to their work and of linking art with the everyday. Messager placed worn-out dresses under glass in wooden display boxes and hung them on the wall like paintings. Her 'Histoire des robes' (History of dresses) series in 1990 is an affirmation of the feminine and dramatically evokes a sense of melancholia and lost identity. Boltanski uses lost property from railway stations to memorialise the unknown owners, personal effects relating to the themes of loss, death and buried memories. They are meant to remind us of the experience of remembering.

Authors often compare the similarities of Yamamoto and Kawakubo's work; the two were friends and soul mates for ten years. Kawakubo also finds beauty in the unfinished, the irregular, the monochromatic and the ambiguous. Placed within the context of Zen Buddhist philosophy, this translates as an appreciation of poverty, simplicity and imperfection.[10] Kawakubo asserts that she does not have a set definition of beauty: 'I find beauty in the unfinished and the random … I want to see things differently to search for beauty. I want to find something nobody has ever found … it is meaningless to create something predictable.'[11]

Kawakubo's conceptualisation is inherent to her philosophy of design as she is always projecting forward to the future, pushing boundaries, so to speak. 'It's not good to do what others do. If you keep doing the same things without taking risks, there will be no progress,' she says.[12] Kawakubo relies on spontaneity in her work. 'I could say that my work is about looking for accidents. Accidents are quite important for me. Something is new because it

(*Opposite*) *Flying saucer* outfit from the 'Pleats Please' collection by Issey Miyake at the spring/summer 1994 Paris parade.

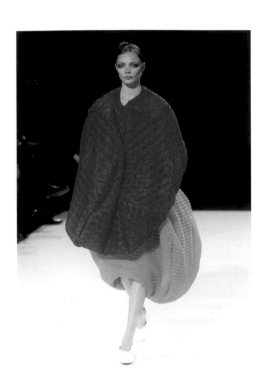

Comme des Garçons 'Body meets dress—dress meets body' collection, spring/summer 1997.

PHOTO: JEAN FRANÇOIS JOSÉ, COURTESY OF COMME DES GARÇONS

is an accident,' she adds.[13] While her work is uncompromising in its anti-fashion directions, like Yamamoto, it is still very personal and self-reflective. 'When I am designing, what's important to me is to express what's happening in my own life, to express my personal feelings through my designs.'[14]

The link that strongly ties Yamamoto and Kawakubo to Miyake is their Japanese heritage. Their embrace of their culture could be read as a backlash to a previous celebration of 'outsider' popular culture. According to a contemporary Kyoto textile artist, after the war there was a growing influence from American popular culture on Japanese society. It seemed that the Japanese people were no longer selectively focused on their cultural heritage, desiring new and novel consumer items rather than cherishing traditional pieces. The kimono, for example, has always played a significant role in the culture of Japan. The great value attached to kimonos and textile design is evidenced by the involvement of some of Japan's most famous artists in the design of the garments, such as the 19th century printmaker Utamaro. Kimonos are handed down from generation to generation and they have defined and contributed to the Japanese tradition of beauty.

All three designers insist that the underlying influence of the kimono in their work is profound. They agree that it is the space between the fabric and the body that is most important. This negates the blatant sexuality of fitted Western clothes and introduces the possibility of layered or voluminous clothing that becomes a sculptural form of its own. Kawakubo comments on the gender-neutral design of her kimono-inspired constructions: 'Fashion design is not about revealing or accentuating the shape of a woman's body, its purpose is to allow a person to be what they are.'[15] This is abundantly clear in her spring/summer 1997 'bump' collection where padded sections added to the clothes to distort the back and hips of the body critiqued the notion of the perfect female shape. This is very much in keeping with postmodernist practice, where self-critique and reflection challenge accepted norms of life and society. Does sexuality always have to be determined by body shape? Kate Betts argues in *Time* magazine that Kawakubo invites an open interpretation of her work but also suggests that this collection calls for some level of self-awareness.[16] Not surprisingly, Kawakubo commented in 1983 that she saw the New York bag lady as the 'ideal woman' to dress, and, in 1984, that a woman who 'earns her own way' is her typical client. Another often-quoted statement of the 1990s refers to how she designed clothes for 'strong women who attract men with their minds rather than their bodies'. This inherent feminist critique, obvious in both her words and her work, was echoed not only in many different forms in arts practice in the 1980s and 1990s (by feminist artists such as Barbara Kruger, Cindy Sherman, Moriko Mori and the Guerilla Girls, amongst others), but in literature, media advertising, film and dramatic production.

Miyake's work comments on the recontextualisation of the kimono to create a different aesthetic milieu. Miyake rejected the traditional forms of Parisian collection clothing. Through the inventive use of fabric and successive layering, he developed a concept of fashion based on the use of cloth, or rather the 'essence' of clothing—the wrapping of the body in cloth. He has created anti-structural, organic clothing which takes on a sculptural quality that suggests a natural freedom, expressed through the simplicity of its cut, the abundance of new fabrics, the space between the garment and the body, and its general

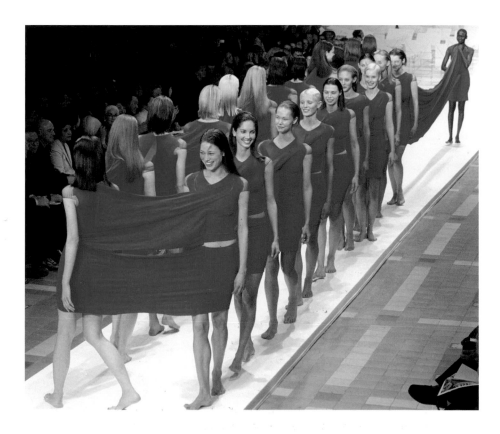

flexibility. 'I learned about space between the body and the fabric from the traditional kimono … not the style, but the space.'[17] Like Kawakubo, Miyake's design also draws on parallels with architecture. His structures in bamboo recall samurai armour, a rigid house for the body, and exemplify the idea of the body moving within a space beneath an outer space.[18]

Similarly, Yamamoto redefined male clothing forms when he introduced his autumn/winter 1985/86 'unstructured' mens' collection with baggy pleated pants—a draped look—that approximated Turkish harem pants. Suit jackets lost their tapered waists, linings and padding were removed and the way sleeves were mounted changed the male silhouette dramatically. Different textiles were used, such as soft, elastic fabrics made of viscose and crepe yarns, this new, redefined form heralding a new direction, towards comfort and simplicity. Perhaps more importantly, Yamamoto saw this new aesthetic as a reflection of a new 'ideal of clothing'. He said, 'People don't "consume" these garments, they might spend their entire lives in them … that's what life is about. Real clothes, not fashion.'[19]

Another major factor that unites the postmodernist work of Yamamoto, Kawakubo and Miyake is their interest in experimentation in textile design. The Japanese fashion empire is built on the framework of its textile industry, just as, for centuries, the French industry has been. This experimentation was evident in Kawakubo's 'lace' or 'Swiss cheese'

Issey Miyake 'A-POC' Paris parade finale, spring/ summer 1999.

sweaters when weaver Hiroshi Matsushita reformulated the actual fabric on the loom to create various sized holes that appear as rips or tears. Some textile designers believed that with growing industrialisation and more complex technologies, a more humanistic approach was needed in the creation of textiles. In Japan, imperfections and aberrations in fabrics are considered precious.[20] Matsushita refers to this as 'loom-distressed weaves'. In postmodernist terms, it is called 'deconstruction'.

Miyake is renowned for his research in textile technology. In the design series 'Pleats Please', which he has worked on for over 10 years with Minagawa, Miyake has created a kaleidoscope of colour in surface patterning akin to the fragmentation of colour as seen on a computer screen.[21] The interplay of pattern and colour is heightened by the technique of heat-set pleating the synthetic garment, so that an origami of pleating results. As the wearer moves, the colours start to dance before your eyes. Pleating became his obsession—he would design a shape first, a pure shape, and then press it into a pleating machine. In 1990, *Interview* magazine quoted Miyake: 'Pleats give birth to texture and shape all at the same time. I feel I have found a new way to give individuality to today's mass-produced clothing.'[22] The 'Pleats Please' series attests to Miyake's desire to produce adaptable, simple clothing that is not only functional but appropriate to a modern lifestyle. 'These clothes are meant to be rolled for travelling and are inexpensive to own. It is like buying a loaf of bread.'

Textiles reference Miyake's cultural heritage in many ways. He has used *shashiko*, a Japanese technique of cotton quilting, for coats. He has also used a fabric called *tabi-ura*, formerly reserved for the bottom of the fitted Japanese sock. Paper, originally used as a warm lining in the winter coats worn by ancient farmers, has been reintroduced in his collection showings. 'There are no boundaries for what clothes can be made from. Anything can be clothing.'[23] He is inspired by the natural forms of shell, seaweed and stone. The oil-soaked paper used so commonly in the traditional Japanese umbrella is re-employed to form a translucent coat: 'the model glows through this golden paper skin, like an insect set in amber … one of Miyake's most innovative images is found in the bark of a tree.' He asked, 'Did you know there's a tree in Africa where the bark comes off completely? It's round, just like a tube of jersey. I wanted to make something woven that was warped like African bark.'[24] His close friend, architect Arata Isozaki, compares this to the hollow, seamless, sacred garments woven for the gods—which were the prototype of clothing: 'It becomes an archetypal dress, a universal, circular form.'[25] Perhaps this served as an inspiration for Miyake's 'A-POC' (A piece of cloth) series in 1999 when he introduced a flat tube of fabric which could be cut into a variety of garments, literally a self-contained wardrobe.

Both appropriation and recontextualisation play a key role in the definition of postmodernist practice. Miyake's 1978 book *East meets west* includes an essay by Arata Isozaki, the architect of the Museum of Contemporary Art in Los Angeles, which consolidates Miyake's link between fashion design and architecture.[26] The publication underlines the close association Miyake has always maintained with other art practitioners. For example, Leni Riefenstahl's photographs of the Nuba stimulated Miyake and fellow art director Eiko Ishioka to view the figures as more than just magnificent bodies, but wonderful abstract patterned surfaces instead. For his autumn/winter 1989/90 'Tattoo Body' collection, Miyake created a series of tattoo-like body-stocking garments worn close to the body, using a stretch fabric.

In embracing ethnic beauty, he treats the garments as a second skin. His collaboration with other visual arts practitioners has not only created a culturally diverse interface in Miyake's work but has also infused it with a richness of symbolic reference and meaning.

Meaning and memory pervade the work of these three key designers. As with the Dada artist Marcel Duchamp, the meaning or the concept of the work was central to its significance to 20th century visual culture. Duchamp introduced the 'conceptualisation' of fine art in the second decade of the 20th century with his 'ready-mades'[27]—everyday objects that he gave titles and exhibited as art (like the common urinal which he called *Fountain* and signed as 'R Mutt')—which dramatically challenged traditional concepts of beauty, uniqueness and innovation in the visual arts. All three Japanese designers rejected change for change's sake, instead choosing to work on the refinement and evolution of previous collections. This evolution of an idea was the basis of Japanese fashion. The notion of serialisation, revisited by many conceptual visual art practitioners since the 1960s, was integral to the Japanese approach to design in the 1980s.

Miyake, Yamamoto and Kawakubo are often described as niche designers—designers who do not follow stylistic trends or directions. Unlike their European and American counterparts, they have not exclusively embraced the revivalist or popular cultural imaging that has inundated Paris catwalks for decades. The riotous and multifarious themes that we see in the repertoire collections of Alexander McQueen, Jean Paul Gaultier and Vivienne Westwood find no place in the work of the Japanese designers. Nor is it likely that these designers will ever be nominated as possible head designers of other mega-fashion houses. Designers such as Karl Lagerfeld, appointed head designer at the House of Chanel, Galliano at Dior, and Ford as the new director at Yves St Laurent, understood that the stylistic vestiges or remnants of the *maison* had to be retained and reflected to some degree in the reconstituted collections. Obviously, the uncompromising nature of the Japanese designers' work eliminates their suitability to fill such a role, despite the fact that Kawakubo was voted the leading designer in Paris in 1987 by the international press.

The conceptual underpinning of their design work also explains why, in the early 1990s, their reputation as leaders in the international fashion arena was consolidated.[28] At this time, Paris designers were bombarded by a mass of media criticism for the apparent excesses of 'unbridled indulgence' which, according to London journalist Juliet Herd, 'spelt the death knell of haute couture'.[29] This 'extinction of the Paris couture industry' was reaffirmed by Pier Berg, the high-profile head of Yves St Laurent, when he stated that 'haute couture will be dead in 10 years time'. The French prime minister, who believed the French fashion industry 'needed an overhaul' in order to survive, called a summit meeting to discuss the troubles of the $3.3 billion dollar ailing export industry. It seems that the exclusivity of the Chambre Syndicale, the industry's powerful authority, prevented the inclusion of the younger, more avant-garde designers in the 'club', and wealthy younger clients were turning to *pret-a-porter* as haute couture 'seemed to be running out of ideas'. Herd argues that 'the lack of originality among top designers was highlighted at the French collections' where, one fashion expert observed, 'Many top couturiers appeared to be wandering up blind alleys, uncertain of their role.' Significantly, there were 21 fashion houses in Paris at this time, all of which considered haute couture the backbone of their business.

By the 1990s, fashion journalists were becoming increasingly critical of the lack of originality and direction in Paris fashion. In their constant search for novelty, some designers were looking back to previous historical periods, while others found a need to react or contradict that which had gone immediately before. This lack of direction seemed to be broadcast in the growing superficiality of styles that led Suzy Menkes, fashion editor of the *International Herald Tribune*, to call the current trends 'caricatures of fashion'.

It could be argued that the designs of Miyake, Kawakubo and Yamamoto offered a meaningful alternative to the superficial, regressive and over-designed work of so many of the Western designers in the 1990s. Their work, more closely allied with postmodernist practice, did not fall neatly within the dictates of the established fashion industry and as a result was not consumed by its self-imposed boundaries. Perhaps this is why it has appealed to noted art photographers such as Irving Penn, Nick Knight, Robert Mapplethorpe, David Sims and Inez Van Lamsweerde, whose images underline the notion that fashion can step beyond its immediate frame of reference. For example, *Issey Miyake: photographs by Irving Penn*, is a collaboration between the Japanese designer and the Western photographer. Three tons of Miyake's designs were shipped to New York where

Irving Penn poster exhibition of Issey Miyake collections at the Ginza Graphic Gallery, Tokyo, 1988.

Penn made his own choices. Penn, like Miyake, 'employs an art of reduction—his fashion photographs are emptied to allow the geometry of his clothes to be the sole, uncluttered force. Penn's photographs are contextless, the subject without the surround'.[30] In a similar way, Japanese landscape and woodblock print artists concentrated their images by juxtaposing them with bare, unadorned elements. Penn presents Miyake's clothing as flattened, near-abstract images in a white nothingness. The clothes disclose nothing of the bodies underneath, so that gender often becomes ambiguous. Penn places Miyake's clothes within a neutral space to underline the notion that fashion can be seen as a re-considered form.

In 1994 Kawakubo worked collaboratively with American postmodernist artist Cindy Sherman to promote her clothing.[31] She sent Sherman garments from each of her collections to use as she wished. Sherman produced a series of unconventional photographs for Comme des Garçons which 'centred on disjointed mannequins and bizarre characters, forcing the clothing itself into the background'. She presented Kawakubo's clothing in masquerade settings, but the confrontational, theatrical images are not about clothes. They are about performance art. Sherman is renowned for her interpretations

Exterior of Comme des Garçons' Aoyama flagship store in Tokyo, designed by Rei Kawakubo in 1999.

"Are you in a Miyake or did you just sleep in your dress?"

'Are you in a Miyake or did you just sleep in your dress?' cartoon by Michael Crawford in the New Yorker.

of mass media stereotypes of femininity. Her critique of 'fashionable' photography is in keeping with Kawakubo's approach to the business of fashion design, itself strongly inspired by the values of the contemporary art world.

As well, Kawakubo deconstructed accepted merchandising strategies by participating in the design of her shop interiors and exteriors. Her minimalist approach encompassed cracked concrete floors, warehouse tables for display of folded goods and old refrigerators as cupboards. In 1999, she designed an architectural landmark building for Comme des Garçons's home base in Tokyo, with a curvy 30-metre expanse of street-level glass screen-printed with blue dots (see p 39). From the outside it creates a pixelated effect, with customers appearing to move across a huge television screen like actors on a set. This type of self-reflexivity reflects the notion that media advertising not only reinforces mass-market consumerism but becomes a reality in itself.

Japanese design has had an unprecedented impact on Western design during the 20th century, and Japan's willingness to embrace the avant-garde is evident in their fine art, their architecture and their fashion design. Miyake, Yamamoto and Kawakubo produce work that is imbued with the history of the past yet looks dynamically towards the future. They have become leaders in the international fashion industry. Their clothing has created a visual language that strengthens the converging line that exists between fashion and art. Miyake is amused when his work is so often referred to as an art form. 'Why?' he replies, 'Clothes are more important than art.'

NOTES

1. R Martin and H Koda, *Infra-apparel*, Metropolitan Museum of Art, Harry Abrams, New York, 1993, p 97.

2. Thorstein Veblen, *The theory of the leisure class: an economic study of institutions*, New York, Macmillan, 1899, p 190.

3. C McDowell, *McDowell's directory of twentieth century fashion*, Prentice-Hall, New York, 1987, p 178.

4. V Carnegy, *Fashions of the decades: the eighties*, Batsford, London, 1990, p 20.

5. An excerpt from the paper entitled 'The aesthetics of poverty' which I presented at the 'Making an Appearance' fashion conference at the University of Queensland, Brisbane, Australia in July 2003, which further outlined the aesthetic differences between Punk fashion and the work of the Japanese postmodernist designers.

6. V Mendes, *20th century fashion*, Thames & Hudson, London, 1999, p 234.

7. A Golden, *Memoirs of a geisha*, Vintage Press, London, 1997, pp 333–49.

8. Yohji Yamamoto, *Talking to myself*, Carla Sozzani Editore, Milano, 2002.

9. F Chenoune, *History of men's fashion*, Flammarion Press, New York, 1993, p 305.

10. R Leong, 'The Zen and the zany: contemporary Japanese fashion', *Visasia*, 23 March 2003 [Online] Available: www.visasia.com.au

11. Y Kawamura, 'The Japanese revolution in Paris', *Through the surface* [Online] 2004:n.p. Available: www.throughthesurface.com/symposium/kawamura

12. *Undressed: fashion in the twentieth century*, video, Little Bird/Tatlin Production, Beckmann Visual Publishers, UK, 2001.

13. Ibid.

14. *The story of fashion: the age of dissent*, video, RM Arts Production, UK, 1985.

15. T Jones, *i.D.—The Glamour Issue*, May 1992, pp 72–3.

16. K Betts, 'Rei Kawakubo: Comme des Garçons, avatar of the avant-garde', *Time*, 16 February 2004, p 40.

17. R Knafo, 'The new Japanese standard: Issey Miyake', *Connoisseur*, March 1988, p 108.

18. M Holborn, 'Image of a second skin', *Artforum*, November, vol 27, 1988, p 120.

19. Chenoune, op cit, p 305.

20. M Niwa, 'The importance of clothing science and prospects for the future', *International Journal of Clothing Science and Technology*, MCB University Press, vol 14, no 3–4, 2002, p 238.

21. Minagawa is a third-generation Kyoto kimono maker esteemed for her exemplary expertise.

22. M K Saiki, 'Issey Miyake: photographs by Irving Penn', *Graphis*, July/August, vol 48, no 280, 1992, p 34.

23. Holborn, op cit, p 120.

24. Nicholas Callaway (ed), *Issey Miyake: photographs by Irving Penn*, A New York Graphic Society Book, Little, Brown & Company, Boston, 1988, p 15.

25. Holborn, op cit, p 121.

26. Issey Miyake, *East meets west*, Heibonsha, Tokyo, 1978.

27. A pun referencing early mass-produced clothing, considered 'cheap and nasty' in the early 20th century.

28. An excerpt from the paper 'Japanese fashion as a re-defined form' which I presented at 'The Space In-Between: Art, Fashion, Textiles' conference held at Curtin University, Perth, Western Australia in April 2004.

29. J Herd, 'Death knell of haute couture', *The Times*, reprinted in *Courier Mail Weekend*, 10 August 1991, p 5.

30. Holborn, op cit, p 118.

31. J Glasscock, 'Bridging the art/commerce divide: Cindy Sherman and Rei Kawakubo of Comme des Garçons' [Online] 2003. Available: www.nyu.edu/greyart/exhibits

Junichi ARAI
Shinichiro ARAKAWA
Yoshiki HISHINUMA
Nozomi ISHIGURO
Rei KAWAKUBO
Tokio KUMAGAI
Masaki MATSUSHIMA
Issey MIYAKE
Hanae MORI
Masahiro NAKAGAWA
Hiroaki OHYA
Reiko SUDO
Kenzo TAKADA
Jun TAKAHASHI
Naoki TAKIZAWA
Aya TSUKIOKA
Kosuke TSUMURA
Junya WATANABE
Yohji YAMAMOTO

DESIGNERS

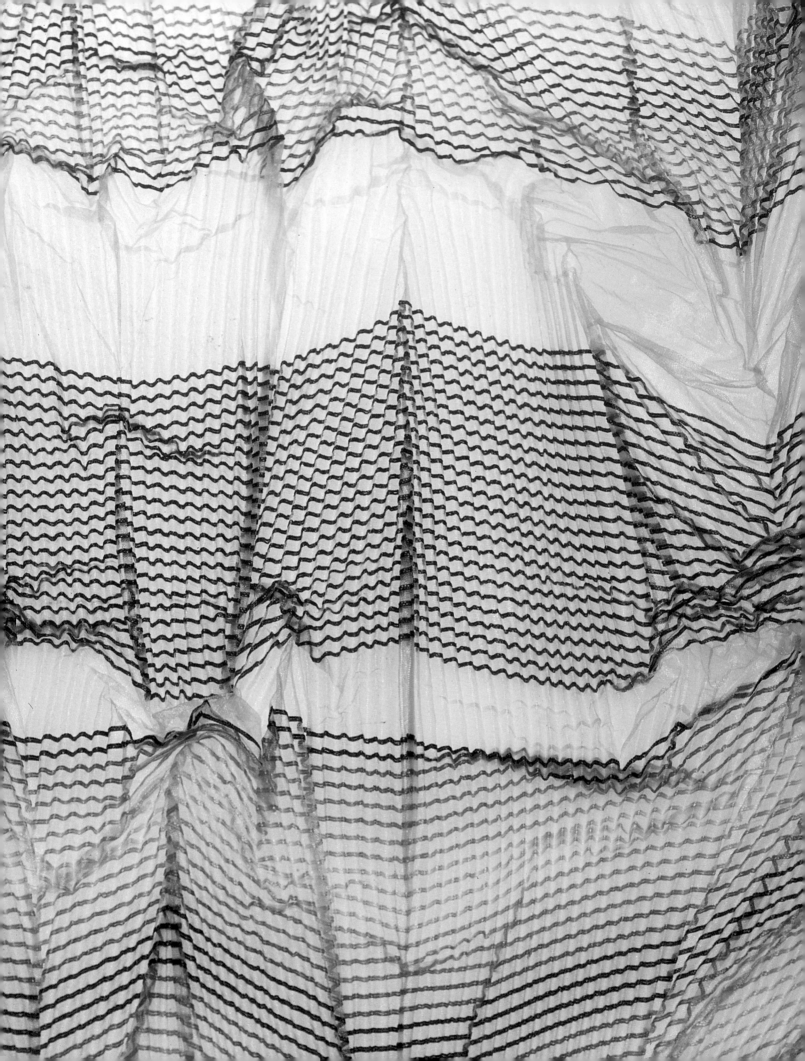

JUNICHI ARAI

b 1932, Gumma

Junichi Arai is a textile designer and weaver world renowned for his groundbreaking and experimental textile work. Arai comes from a family of weavers in the traditional textile centre of Kiryu. He began his career in his father's kimono factory while studying textile courses at Gumma University. In the mid 1950s Arai started experimenting with metallic yarns and chemically altered fibres. By the 1970s he was exploring the possibilities of using computers for fabric design and production. In 1984 he co-founded the innovative Tokyo-based textile design company, NUNO Corporation, with Reiko Sudo and over the years he has worked closely with the fashion industry, creating interesting textiles for designers such as Rei Kawakubo, Yohji Yamamoto, Yoshiki Hishinuma and Issey Miyake. He has conducted textile workshops all over the world, and his works are included in the collections of major museums.

Yuragi (pictured) is a polyester and nylon cloth manufactured using a combination of heat-set pleating and a 'melt-off' technique. Developed by Arai around 1979, melt-off is a technique whereby the metallic element in a slit-film thread is dissolved, leaving behind a filmy, transparent cloth, in this case with stripes of multicoloured threads through it. Metallic slit-film threads are produced by applying metal to a material such as polyester which is then slit into fine strips that can be woven into a textile.[1] The textile was also pleated and heat-set, using a heat-transfer print machine in order to retain the pleats permanently. The combination of materials and techniques creates a rustling, 'crushed' fabric with three-dimensional and light-reflective qualities.

1. Metallic fabrics have been used for centuries in Japan to achieve a luxurious surface on kimonos. Traditionally, metal-leafed paper would be twisted around an inner yarn to form a thread for weaving or embroidery. With the development of synthetics, the most commonly used method is a single-ply polyester film metallicised, lacquered and slit into strips to form a thread known as polyester slit-film. Japan is a leading producer of this thread. See Cara McCarty and Matilda McQuaid, *Structure and surface: contemporary Japanese textiles*, The Museum of Modern Art, New York, 1999.

(*Opposite*) *Yuragi* (Fluctuation), textile length (detail)
Designed by Junichi Arai in 1985
Polyester/nylon
270 x 85 cm
Made by Daito Pleats Co Ltd and Oike Industrial Co Ltd, manufactured 1994.
COLLECTION: POWERHOUSE MUSEUM 2001/65/1, GIFT OF JUNICHI ARAI 2001
PHOTO: SUE STAFFORD, PHM

(*Above right*) Junichi Arai with one of his textiles.
PHOTO: COURTESY JUNICHI ARAI

SHINICHIRO ARAKAWA

b 1966, Kiryu, Gumma prefecture

Shinichiro Arakawa completed a general arts course in Tokyo before moving to France in 1989. He worked briefly for English designer Sam Nemeth and studied fashion at the Studio Bercot, Paris, before launching a small-scale show during the Paris pret-a-porter collection week in 1993. He established a shop in Paris's Marais district and showed twice a year from 1994 to 1996, when he decided to return to Tokyo. Since returning to Japan, Arakawa has worked as both a fashion designer and interior designer. In 1997 he began a collaboration with Honda when he was selected to design a new line of garments for the Honda 'Motorbikes-Sports' brand. He produced a limited-edition collection under the label 'Shinichiro Arakawa-Honda'.

Arakawa presented his autumn/winter 1999/2000 collection in a Paris art gallery. The walls were lined with 'canvasses' of stretched fabric that showed the outlines of garments. In front of the frame, Arakawa placed a model wearing a replica of the stretched and framed garment. Instructions accompanying the framed clothes read: 'Take the canvas out of the frame. Put your head through the opening and stick your arms through the armholes. Wrap the fabric round your body and do up the zip or buttons. The garment is now ready to wear.' In line with the work of other Japanese designers of his generation, Arakawa's work shows considerable technical ingenuity. Arakawa is not presenting a new style but rather spotlighting the garment itself, inviting a closer scrutiny of its design and construction.

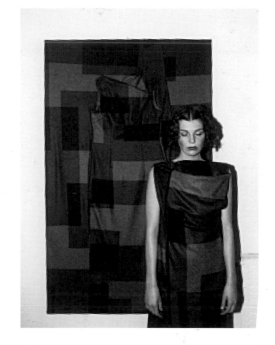

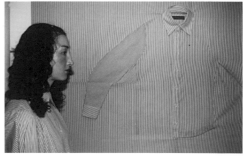

(*Opposite*) Dress (presented in a frame)
Autumn/winter 1999/2000
Wool twill

COLLECTION: KYOTO COSTUME INSTITUTE AC9773

PHOTO: TAKASHI HATAKEYAMA, COURTESY KCI

(*Above right*) Gallery presentation of Arakawa's 'picture collection' in Paris, 2000.

PHOTOS: COURTESY SHINICHIRO ARAKAWA

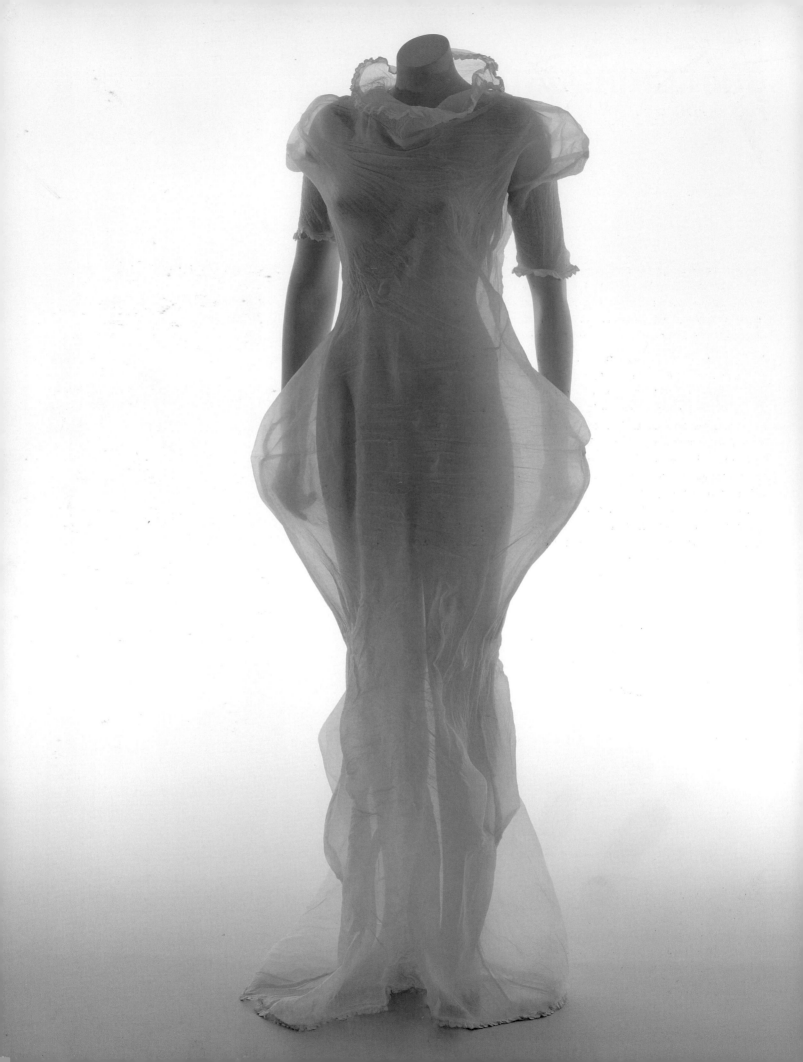

YOSHIKI HISHINUMA

b 1958, Miyagi prefecture

Yoshiki Hishinuma studied at the Bunka College of Fashion in Tokyo and worked briefly for the Miyake Design Studio during 1978. In 1985 he established the Hishinuma Design Studio, a small Tokyo establishment where reliance on technology is matched by handwork. Highly inquisitive about textiles, Hishinuma enjoys working with skilled textile engineers to produce fabrics and garments with an individual quality.

The application of traditional Japanese techniques within a technologically advanced textile industry has made for some of the most innovative fashion in Japan. When *shibori*, a resist-dyeing technique practised in Japan for centuries, is used by textile artists and fashion designers on polyester under special conditions of heat, they can permanently texture the fabric or create three-dimensional effects. High heat is used in place of dye in the *shibori* process. Working closely with a textile engineer and a yarn twister, Hishinuma developed a polyester fabric that stretched and pulled under high heat. A wooden mould shaped like a small propeller was made to permanently imprint three-dimensional shapes in the fabric by laying a constructed garment over the mould, tying it down tightly and securely, and then boiling it to activate the shrinking of the exposed parts. The result is a 'sculptured' dress with panniers that seem to 'float' from the wearer's body (pictured). The finished garment does not require the usual cutting and darting to fit the shape of the wearer as it simply stretches and hugs the body.

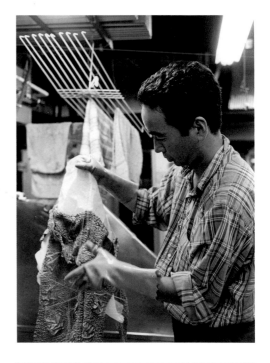

(*Opposite*) Dress
Spring/summer 1998
Polyester

COLLECTION: POWERHOUSE MUSEUM 2005/130/1, GIFT OF YOSHIKI HISHINUMA 2005

PHOTO: MARINCO KOJDANOVSKI, PHM

(*Above right*) Yoshiki Hishinuma at work in his Tokyo studio.

(*Below right*) Wooden propeller mould used by Hishinuma to permanently shape polyester.

PHOTOS: COURTESY HISHINUMA STUDIO

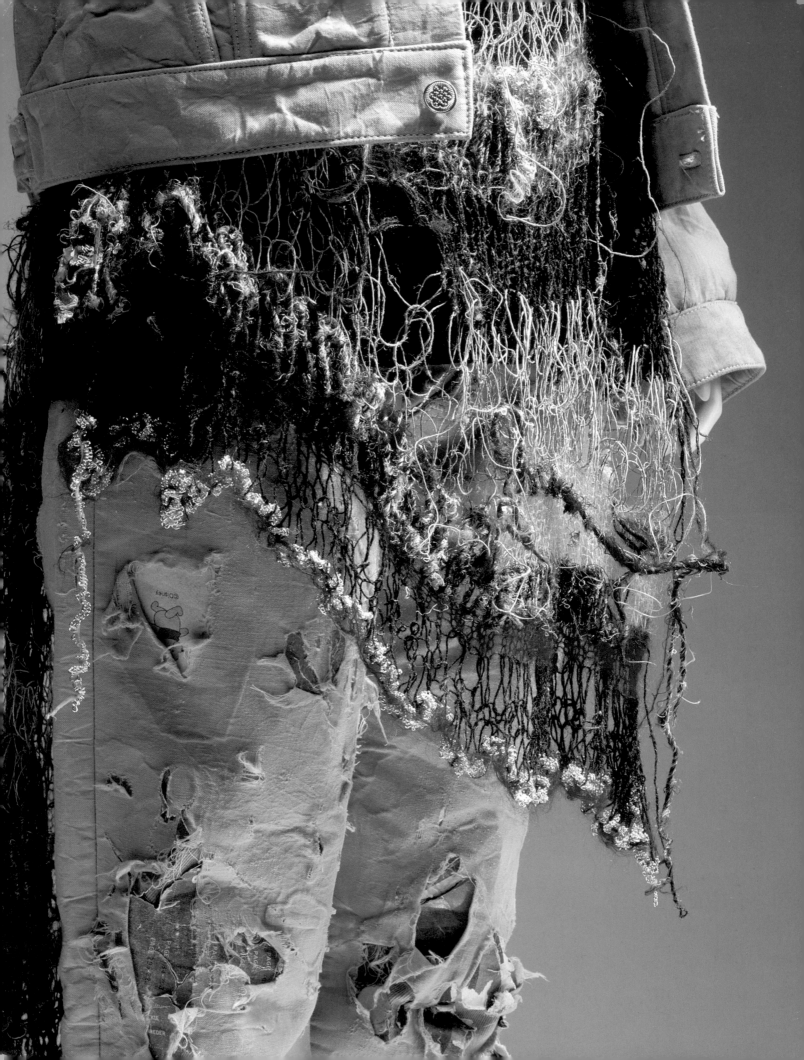

NOZOMI ISHIGURO

b 1964, Tokyo

Nozomi Ishiguro studied at the Kuwasawa Design Institute and then worked for Comme des Garçons between 1985 and 1997 before striking out on his own. From a small studio in Tokyo, he produces limited editions of 'found' clothes that he alters using time-consuming manual techniques. This could involve: applying pieces of fashion magazines and photographs to a pair of leather shoes; covering the surface with *sureki* fabric (a type of thin cotton) then filing back the surface to give a distressed finish; using spray adhesive to apply a collage of magazine cut-outs with anti-war messages to an existing denim jacket and then lining it with *sureki*; giving a wool hat a new lease of life with the application of ink-jet printer dyes on paper steamed onto the hat so that the colours run (pictured below); or applying computer-scanned patterns to fabric.

Ishiguro has also made trousers using a double layer of denim and printed cotton, sandwiching dust, scrap cloth, elastic bands, plastic bags and snack packages between the layers. When the trousers are washed, the denim tears to reveal the printed fabric and sandwiched materials (pictured left). Ishiguro is not interested in buying new fabric to make his clothes, preferring to source existing clothes and textiles that for him contain memories and meaning.

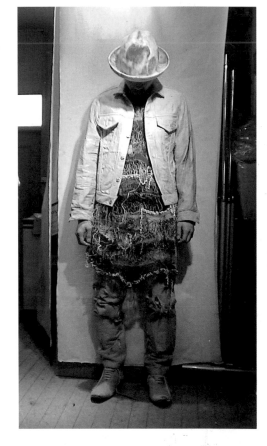

(*Opposite and top right*) Man's outfit
Autumn/winter 2004/05
Shirt, jacket, hat and shoes
Mixed media
Detail showing the hand-knitted wool string vest and the trousers which reveal, through tears in the denim, the inner printed fabric and sandwiched materials.

COLLECTION: KYOTO COSTUME INSTITUTE AC11180

PHOTOS: TAKASHI HATAKEYAMA, COURTESY KCI (DETAIL) AND NOZOMI ISHIGURO

(*Right*) Wool hat with ink-jet printer dyes.

PHOTO: COURTESY NOZOMI ISHIGURO

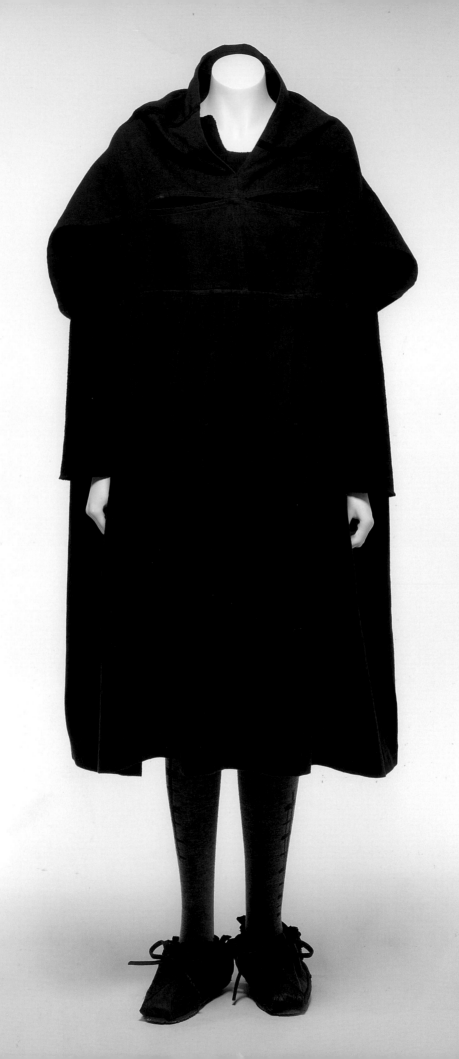

REI KAWAKUBO

b 1942, Tokyo

New dressing

Bernadine Morris wrote in *The New York Times* in 1983:

> The fashions that have swept in from the East represent a totally different attitude
> toward how clothes should look from that long established here. They aim to
> conceal, not reveal the body. They do not try to seduce through colour or texture.
> They cannot be described in conventional terms because their shape is fluid, just
> as their proportions are overscale. Where the hemline is placed, or where the
> waistline is marked is immaterial … Rei Kawakubo of Comme des Garçons is
> widely recognised as having the purest vision and the most powerful approach
> to fashion … There is hardly a glimpse of the body as arms were thrust
> through openings in capelike tops, and clothes were layered in the prevailing
> Japanese manner.[1]

Rei Kawakubo graduated from Keio University in 1964. Dissatisfied with the clothing
available and despite a lack of formal fashion training, she introduced the Comme des
Garçons (Like some boys) label and started production of women's wear in 1969. Comme
des Garçons Co Ltd was established in Tokyo in 1973. With Yohji Yamamoto, her partner
at the time, she showed a Comme des Garçon collection in Paris in 1981 and immediately
received international attention for her unconventional approach to fashion. Kawakubo's
clothes were typically black and oversized, often with an asymmetrical cut, and featured
uneven hemlines, frayed edges and loom-distressed fabric. The clothes appeared ragged
and were embellished with intentional flaws such as slashes and holes. They hung loosely
on the body, as Kawakubo draped and wrapped rather than cut and shaped. Accessorised
with utilitarian flat-heeled shoes, Kawakubo clothes were not differentiated as evening or
daywear.

Kawakubo's clothes challenged many of the tenets of Western fashion in the early 1980s.
Reaction from the fashion media was extreme, with some writers using derisory terms
such as 'Japanese bag lady look' and 'Hiroshima chic'. However, Kawakubo's clothes
proved influential and wearable, for sombre colours, oversized clothing, textured fabric and
asymmetrical detailing had become popular by the mid 1980s. It was a style that resonated
with London's anti-establishment Punk movement and embodied a strand of Japanese
aesthetics and philosophy that emphasises irregularity, imperfection and the unfinished.

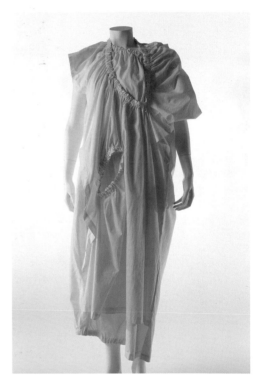

(Opposite) Outfit
Autumn/winter 1983/84
Top, dress, stockings and shoes
Black cotton dress with distressed pattern; black wool jersey top;
wool blend patterned tights; black leather shoes.

COLLECTION: POWERHOUSE MUSEUM, 2000/38/2, GIFT OF BEVERLEY COX 1999

PHOTO: MARINCO KOJDANOVSKI, PHM

(Top right) Dress
Spring/summer 1984
Cotton with cutwork and shirring

COLLECTION: KYOTO COSTUME INSTITUTE, AC7909, GIFT OF COMME DES GARÇONS CO LTD

PHOTO: TAKASHI HATAKEYAMA, COURTESY KCI

Photo by Peter Lindbergh of Lindsey.

PHOTO: © PETER LINDBERGH, PARIS, FRANCE, 1983, COURTESY MICHELE FILOMENO SARL

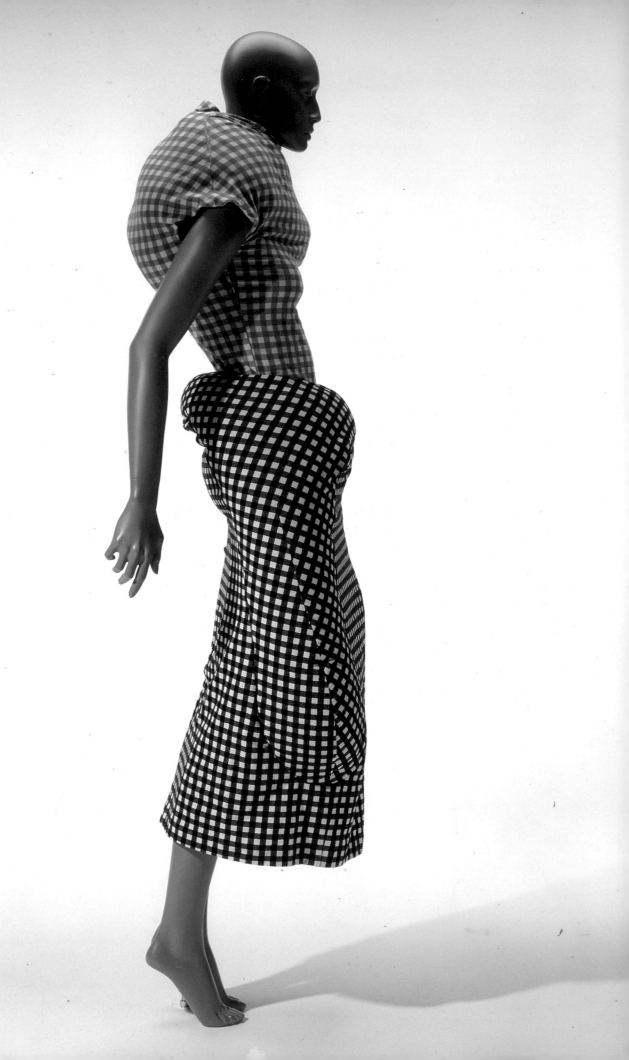

'Body meets dress—dress meets body'

Since the launch of her Comme des Garçons collection in Paris in 1981, Rei Kawakubo has been recognised as a leading avant-garde designer of international fashion and her clothes have been celebrated for their ability to challenge traditional notions of feminine allure in women's dress. Her Comme des Garçons spring/summer 1997 collection, sometimes referred to as the 'Bump' collection, perplexed even her most loyal followers, featuring as it did tight tops and skirts in bright stretch gingham that were swollen with plump, goosedown-filled lumps and coils.

Padding has a precedent in historical Western dress—for example, the hip pads worn to create the fashionable silhouette of the 1700s or the paddings used to stuff the leg-of-mutton sleeves of an 1830s dress. Kawakubo's vision was not to enhance the contours of the body but to place the padding in unlikely positions so that buttocks, torso and shoulders appeared distended, extended and relocated. While many found the clothes unnerving and unflattering, others found the collection visionary. The choreographer Merce Cunningham used Kawakubo's designs for a dance piece titled *Scenario*. To Cunningham the designs recalled 'a man in a raincoat and a backpack [and] a woman in shorts with a baby on her side … shapes we see every day'.[2]

From the beginning of her career, Kawakubo has aimed to express something new with each collection. In an interview for a Japanese fashion magazine she explained her motivation for the spring/summer 1997 collection:

> I was trying out three approaches with that collection. I wanted to find something from a different angle to anything I had done up until then. I wanted to design the body itself, and I wanted to use stretch fabrics. At that time, I felt there was nothing that gave me conviction. I was keenly aware of the difficulty of expressing something using garments alone. And that is how I arrived at the concept of designing the body.[3]

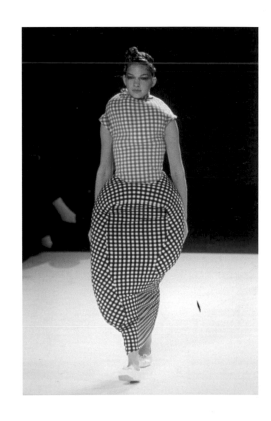

(*Opposite*) Dress
'Body meets dress—dress meets body' spring/summer 1997
Nylon, urethane, goosedown and feather

COLLECTION: KYOTO COSTUME INSTITUTE

PHOTO: YASUSHI ICHIKAWA, COURTESY KCI

(*Right*) Comme des Garçons collection, spring/summer 1997
on the catwalk.

PHOTO: JEAN FRANÇOIS JOSÉ, COURTESY OF COMME DES GARÇONS

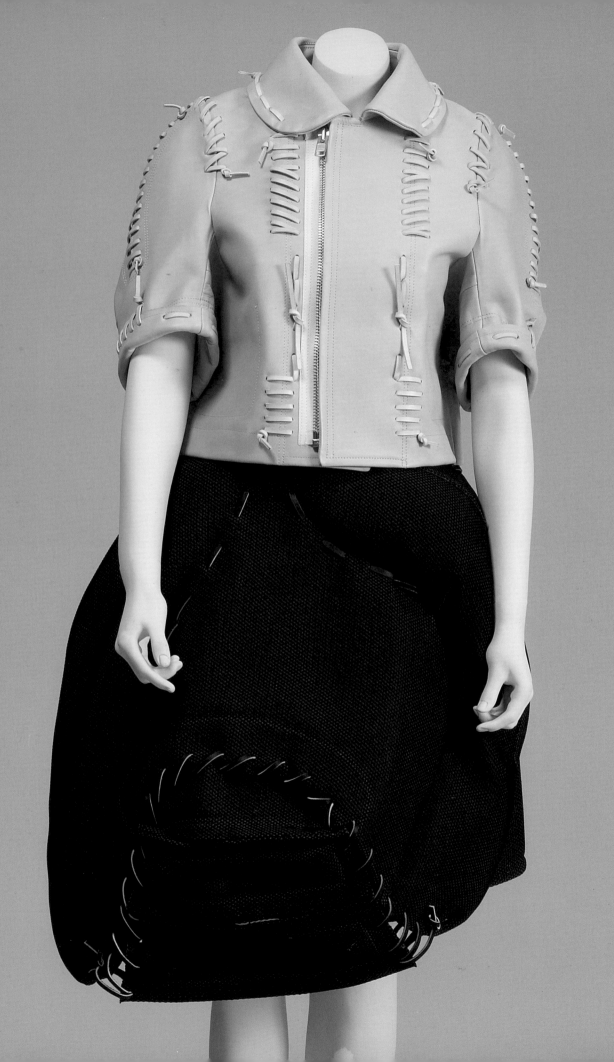

Contemporary collections

The much-quoted remark, 'I work with three shades of black', belies the fact that Rei Kawakubo's collections have more often than not incorporated colour. Over the past three decades her clothes have ranged from the sombre, oversized, asymmetrical garments characteristic of the early 1980s, and with which she is so often associated, to colourful, light-hearted, structured garments that often reference historical Western fashion and are sometimes in keeping with prevailing trends.

Rather than developing or reworking a signature look, Kawakubo's stated aim is to continue to create something completely different from her previous collection. An overview of recent collections is testimony to this approach. The autumn/winter 2001/02 collection was inspired by kitsch lingerie and featured the incongruous combination of corsets and bras worn over men's business suits. The next year Kawakubo explored the latest developments in knitting and produced a collection of elegant, innovative dresses that corkscrewed around the body. In another recent collection, entitled 'Abstract Excellence', Kawakubo focused on the skirt, with skilfully cut garments that emphasised the inherent quality of the fabric. For spring/summer 2005, the inspiration for a collection of leather jackets teamed with tutus and rubber shorts and skirts was 'the power of the motorbike and the strength of ballet dancers' arms' in yet another exploration by the designer of a feminine ideal.

Kawakubo's multidisciplinary output is seen in the biannual *Six* (for sixth sense) magazine (produced 1988 to 1991), collections of inspirational images devoid of text; of furniture and architectural designs; and of collaborations with photographers and choreographers.

1. Bernardine Morris, 'The Japanese challenge to French fashion', *The New York Times*, March 1983.
2. Harold Koda, *Extreme beauty: the body transformed*, Metropolitan Museum of Art, New York, 2002.
3. Interview with Sarah Mower, 'Talking with Rei', *Vogue Nippon*, September 2001, pp 156–9.

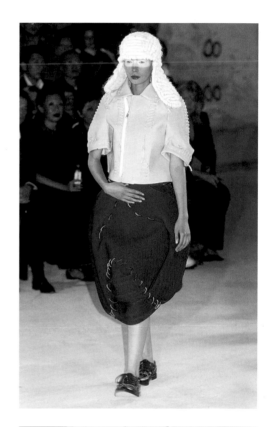

(*Opposite and right*) Women's outfit
'Harley Davidson x ballerina' spring/summer 2005
Skirt, jacket and shorts
Leather and rubber

COLLECTION: POWERHOUSE MUSEUM 2005/174

PHOTO: MARINCO KOJDANOVSKI, PHM

(*Top right*) Comme des Garçons 'Harley Davidson x ballerina' spring/summer 2005 collection

PHOTO: JEAN FRANÇOIS JOSÉ, COURTESY COMME DES GARÇONS

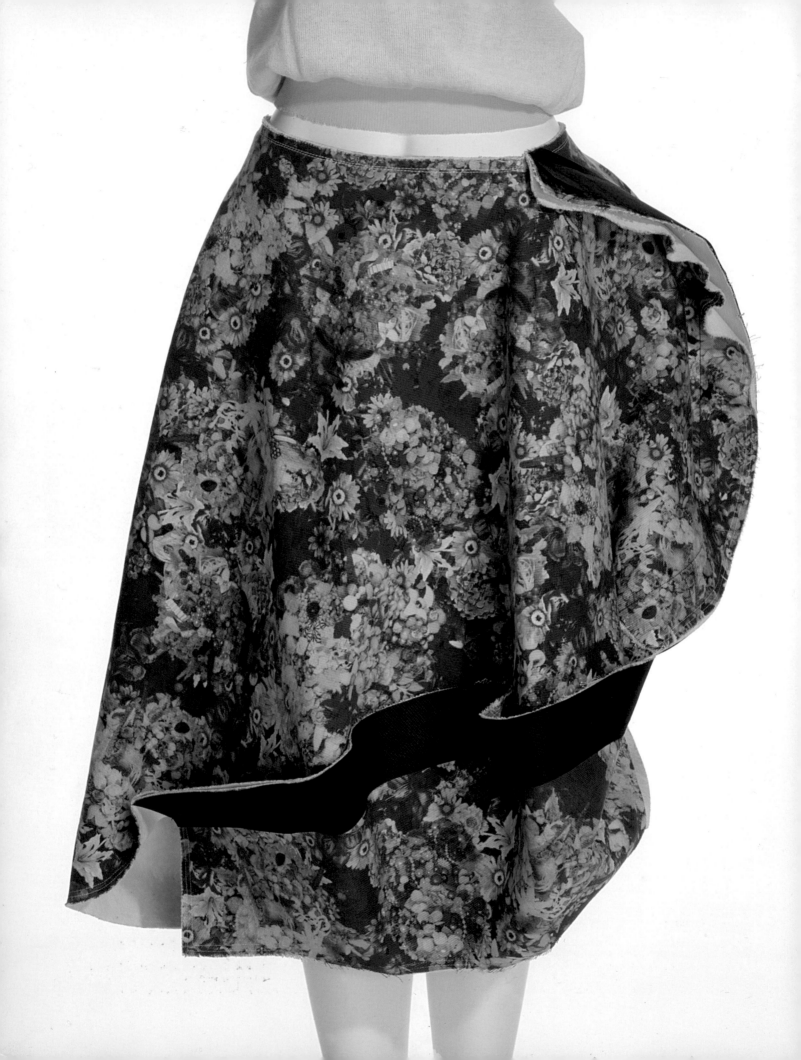

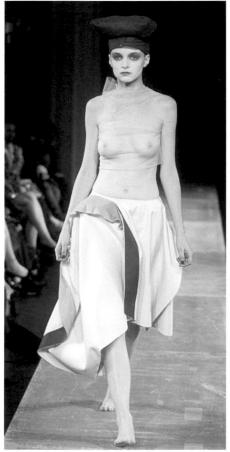

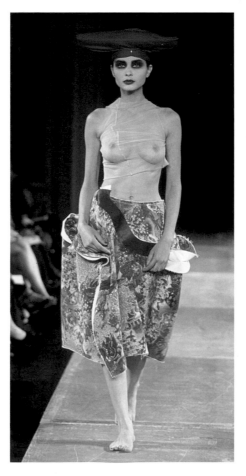

(*Opposite*) Skirt
'Abstract Excellence' spring/summer 2004
Cotton/polyester
Print by Ruriko Murayama

COLLECTION: KYOTO COSTUME INSTITUTE
PHOTO: YASUSHI ICHIKAWA, COURTESY KCI

(*Clockwise from top left*)
'Transformed Glamour', Comme des Garçons
autumn/winter 1999/2000
'Optical Power', Comme des Garçons
spring/summer 2001
'Beyond Taboo', Comme des Garçons
autumn/winter 2001/02
'Abstract Excellence', Comme des Garçons
spring/summer 2004

PHOTOS: JEAN FRANCOIS JOSÉ, COMME DES GARÇONS

TOKIO KUMAGAI

1947–87, born Sendaï

Tokio Kumagai was one of the most inventive shoe designers of the 20th century. After graduating from Tokyo's Bunka College of Fashion in 1970, he settled in Paris, working for the fashion house Castelbajac, and later with Cerruti in Italy. In 1980 he opened his first shoe boutique in Paris. Until his death in 1987, Kumagai produced numerous inventive shoes, many inspired by the art of Salvador Dali, Vasily Kandinsky, Piet Mondrian and Jackson Pollock, many others playfully mimicking subjects such as sportscars, mice or African art.

In his *Taberu kutsu* (Shoes to eat) series, first produced in 1982 for an exhibition in Tokyo, Kumagai used Japanese plastic food-sample production methods to create shoes incorporating hyper-real representations of beef, red-bean rice and ice-cream sundaes.[1] His quirky, inventive designs continued a tradition of illusionary techniques seen in fashion earlier in the century, in particular Parisian couturier Elsa Schiaparelli's surrealist-inspired designs of the late 1930s.

1. Puck van Eenennaam-Meijer, *Tokio Kumagai shoes*, Dutch Leather and Shoe Museum, 1991, p 32.

(*Opposite*) Sandals
Taberu kutsu (Shoes to eat) series
About 1984
Resin; imitation red beans and rice

COLLECTION: KYOTO COSTUME INSTITUTE AC7560, GIFT OF TOKIO KUMAGAI

PHOTO: MASAYUKI HAYASHI, COURTESY KCI

(*Top right*) **Court shoes with high heels**
Taberu kutsu (Shoes to eat) series
About 1984
Resin; imitation beef

COLLECTION: KYOTO COSTUME INSTITUTE AC7558, GIFT OF TOKIO KUMAGAI

PHOTO: MASAYUKI HAYASHI, COURTESY KCI

Stilettos
Taberu kutsu (Shoes to eat) series
About 1984
Resin; imitation ice-cream sundaes

COLLECTION: KYOTO COSTUME INSTITUTE AC7561, GIFT OF TOKIO KUMAGAI

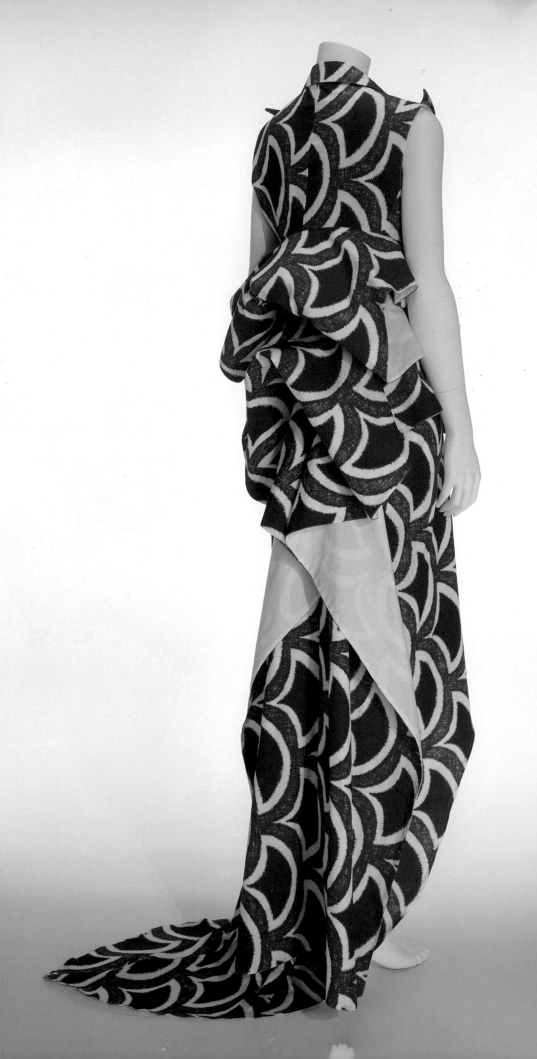

MASAKI MATSUSHIMA

b 1963, Nagoya

Masaki Matsushima graduated from the Bunka School of Fashion in Tokyo in 1985 and immediately began work as an assistant for shoemaker Tokio Kumagai. He became chief designer for the label in 1990. In 1992 he established his own clothing label which he debuted in Tokyo. He has been participating in the Paris collections since 1994 and divides his time between Paris and Tokyo.

Matsushima enjoys experimenting with cut and construction. For example, for his autumn/winter 2000/01 collection he designed garments that at first look like traditional Japanese cushions but ingeniously fold out and transform into women's and men's coats.[1] The influence of traditional Japanese aesthetics is also seen in the silhouette, cut and the fabrics used in his spring/summer 1997 collection.

Fashion inspired by traditional Japanese aesthetics was first seen in Europe after Japan opened its ports to foreign trade in 1853. Japonisme, the Western assimilation of basic Japanese aesthetics, was evident in fashionable dress decorated with Japanese-style motifs in the second half of the 1800s and later in the cut of dresses reminiscent of kimonos. In contemporary fashion, the image of Japan continues to be an inspiration. The recent phenomenon of Japanese-inspired fashion has been described as Neo-Japonisme.[2]

1. From *Made in Japan*, Centraal Museum, Utrecht, 2001.
2. Akiko Fukai, *Japonism in fashion*, National Museum of Modern Art, Kyoto, 1994.

(*Opposite*) **Dress**
Spring/summer 1997
Cotton printed with red fish-scale pattern

ISSEY MIYAKE

b 1938, Hiroshima

'A piece of cloth'

Issey Miyake is a major figure in international fashion and one of the first Japanese fashion designers to gain such recognition. He was the first of the Japanese designers to establish an avant-garde, Japanese–Western hybrid fashion on an international level. Miyake graduated as a graphic designer from Tama Art University in Tokyo before enrolling with the Chambre Syndicale de la Couture Parisienne, working as an assistant to Guy Laroche and Hubert de Givenchy from 1966 to 1969. While in Paris he witnessed the 1968 student demonstrations, which led him to think about designing clothes that were more democratic. He worked briefly in merchandising, with fashion designer Geoffrey Beene in New York, before setting up the Miyake Design Studio (MDS) in Tokyo in 1970, at a time when Japan was undergoing profound cultural and economic changes. Critic Mark Holborn has written that Miyake's career corresponds exactly to the recovery of the nation: 'The prevalent Americanisation of the occupation was replaced by the possibility of an independent Japanese culture which accommodated both native and western traditions with a new modernity.'[1]

From the beginning, Miyake's team at MDS set about researching Japanese folk culture, traditional textiles and clothing techniques such as wrapping and layering. One of Miyake's preoccupations is to create garments that would seem to have been made from a single piece of cloth with no visible seams or fastenings. During the 1970s garments in his series entitled *A piece of cloth* were each essentially a square with sleeves. With their minimalist appearance, these clothes were in the spirit of the kimono rather than that of Western clothing. In Western tailoring, cloth is cut to the shape of the body and sewn, and the space between body and garment is eliminated. In the kimono tradition, the dimensions of the garment are unchanging; the cloth wraps the body and the surplus is left hanging. In discussing his approach to clothing and its connection with the body, Miyake has said:

> I am interested in the space between the body and the clothes so that the body can feel entirely at ease. Because each person's body shape is different, this space creates an individual form. It also gives the wearer freedom of movement for body and spirit.[2]

The outfit opposite illustrates the type of hybrid East-West garment that became identified with Japanese fashion during the 1980s. The oversized or 'one-size-fits-all' outfit is made up of a coat dress worn over a jacket. The textured and patterned fabric in browns and black has a homespun look. Loosely enveloping the body, the coat crosses and folds at the front and is sashed at the waist by lengths of knitted wool. The completed anti-structural look is built up in layers to create volume and form.

1. Mark Holborn, *Issey Miyake*, Taschen, Tokyo, p 24.
2. Lecture at the Los Angeles County Museum, May 1987. Cited in Jun I Kanai, '*Fuku* (clothing) which brings *fuku* (happiness)', *Issey Miyake: Ten Sen Men*, Hiroshima City Museum of Contemporary Art, Tokyo, 1990, p 75.

(*Opposite*) **Outfit**
Autumn/winter 1983/84
Shirt, dress, headwrap, tights and shoes
Wool, cotton, linen

COLLECTION: NATIONAL GALLERY OF AUSTRALIA, CANBERRA
PHOTO: NATIONAL GALLERY OF AUSTRALIA

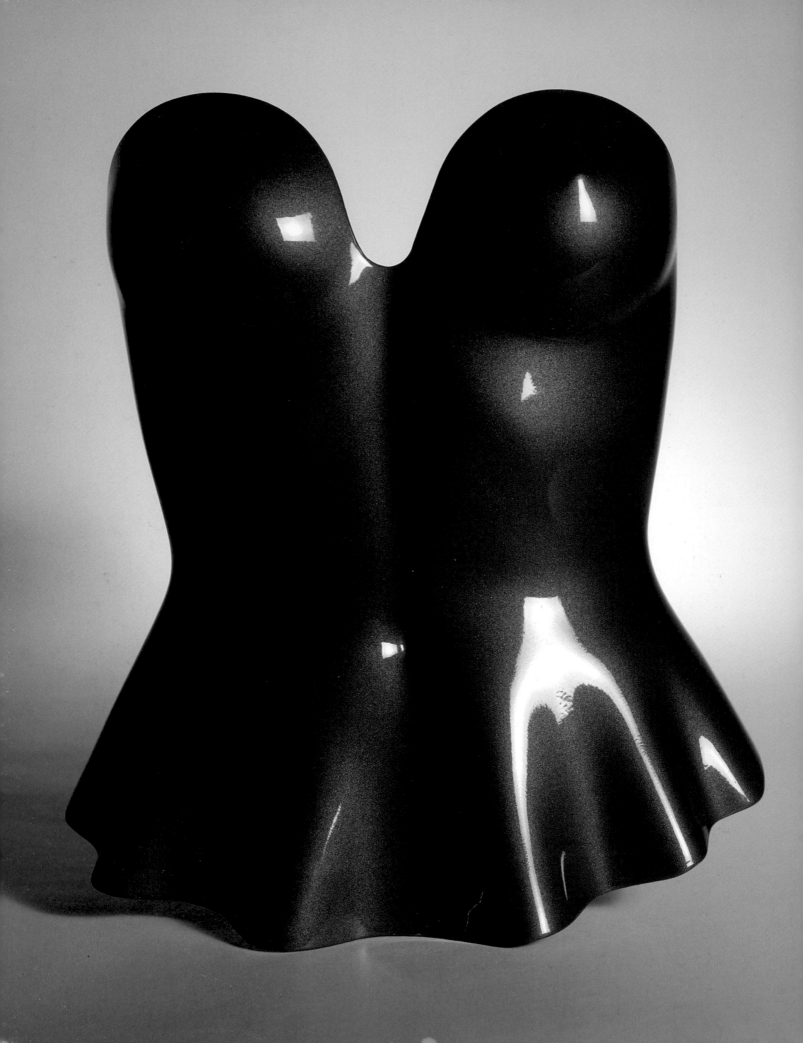

Bodyworks

Apart from designing functional clothes, Issey Miyake has presented spectacular museum exhibitions showcasing the development of more experimental designs, techniques and materials. Between 1983 and 1985, Miyake staged *Bodyworks,* an exhibition exploring the relationship between the body's form and the garment, in museums in Tokyo, London, Los Angeles and San Francisco. The red fibreglass bustier was a centrepiece of the exhibition. Sometimes displayed with a long skirt, it was also hung by itself, like a piece of sculpture.

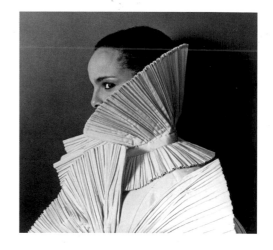

Moulded on an idealised female form, the armour-like form of the bustier replicates the body and then exposes it in a second, fibreglass skin. Reminiscent of the strapless bustiers popularised by Hollywood sex symbols in the 1950s, the bustier's hard industrial surface also recalls the fluid bodywork of a car, while the fluted edge below the waist imitates the soft drapery of clothes.

By showcasing his experimental designs in exhibitions, Miyake has been able to explore ideas that go beyond the catwalk and boutique. A decisive point for the collision of art and fashion occurred in 1982, when a leading art theory journal, the New York magazine *Artforum,* featured Miyake's rattan bustier (also see p 28) from the *Bodyworks* exhibition on its cover. Ingrid Sischy stated in the editorial:

> Issey Miyake's jacket is a paraphrase of light practice Samurai armour which was made of bamboo and often decorated with designs that doubled as a scoring system … It is also a metaphor for a certain relationship to nature. The outfit is a contemporary second skin; its bodice is both cage and armour, lure and foil. The artificial shoulders of this 'iron butterfly' evoke the assertiveness and weaponry of pioneer woman—space invader. Eastern and Western, a picture of fashion—she's a legend.

In a later essay Sischy recollected that Miyake's designs for *Bodyworks* were a 'modern convergence of signs'.[1]

1. Ingrid Sischy, 'Behind the scenes recollections', in Maria Luisa Frisa and Stefano Tonchi (eds), *Excess, fashion and the underground in the 80s*, Edizioni Charta, Milan, 2004.

(*Opposite*) Bustier
1980
Fibreglass
39 x 34 x 15 cm
COLLECTION: NATIONAL GALLERY OF AUSTRALIA, 2000.228
PHOTO: NATIONAL GALLERY OF AUSTRALIA

(*Top right*) 'Shari Belafonte wearing Issey Miyake',
gelatin silver photo by Marcus Leatherdale, 1983.
PHOTO: © MARCUS LEATHERDALE, COURTESY NATIONAL GALLERY OF AUSTRALIA, CANBERRA

Issey Mikaye's spring/summer 1982 collection featured on the cover of *Artforum*, New York, special edition, February 1982.
PHOTO: COURTESY STATE LIBRARY OF NSW

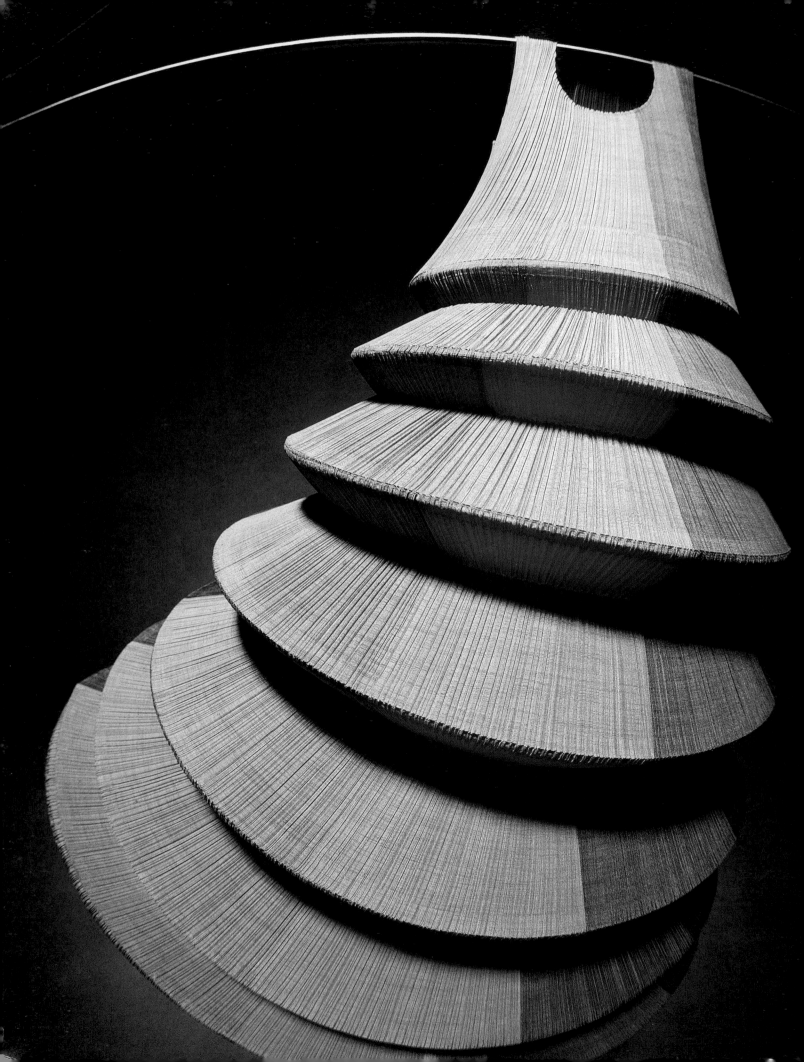

Pleats

> Pleated clothes are made of fabric with folds. Like a child, I play with design in this material. Pleats move and change form with the wearer's body movements. As the pleats move they change colours, giving an optical illusion like a kaleidoscope. Pleats contain endless fascination for me, and inspire a multitude of images.[1]

Issey Miyake began to develop a range of pleated clothes, later launched commercially as 'Pleats Please', in 1988. Pleated clothing has historical roots in the ancient dress of Egypt and Greece. More recently, pleated clothing was recast by Mariano Fortuny (1871–1949) in the early 1900s, with pleated silk dresses that fell from the shoulders and clung softly to the body, emphasising the female form. Miyake's innovation is to reverse the conventional method of pleating fabric before cutting it to the design. Instead, he cuts and assembles a garment two-and-a-half to eight times its proper size. The fabric, a lightweight stretch polyester, is then folded, ironed and oversewn so that the straight lines remain in place. The garment is then placed in a press from where it emerges with permanent pleats.[2]

One of the most stunning variations of Miyake's pleated garments is the *Minaret* dress featured in his spring/summer 1995 collection. Woven with wide vertical stripes in greens, oranges and grey, the lantern-shaped dress is given its bold silhouette by a series of nylon hoops that begin at waist height and increase in size to the ankle. Like a folding paper lantern, the dress folds down into a flat circular form. It can be appreciated in its unworn folded state as well as when it dramatically encases the body and sways with movement.

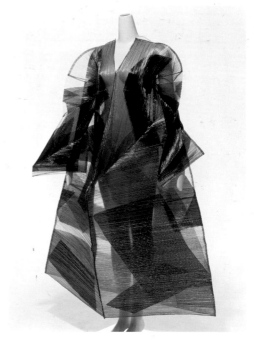

For all their aesthetic and technical innovation, Miyake's pleated garments have proved commercially successful. Their extra lightweight, handwashable, fast drying, easy to store qualities, and their availability in appealing colours, have ensured that the 'Pleats Please' range, launched in 1993, has been commercially successful. Miyake has successfully combined his interest in textile innovation with his condition that clothing be easy to wear.

1. Issey Miyake, 'Ten Sen Men: clothing that communicates', *Issey Miyake: Ten Sen Men*, The First Hiroshima Art Prize, Hiroshima City Museum of Contemporary Art, 1990, p 23.
2. Kazuko Sato, 'Freedom clothes, Issey Miyake', *Domus* 798, November 1997, p 100.

(*Opposite and top right*) *Minaret* dress
Spring/summer 1995
Polyester

COLLECTION: POWERHOUSE MUSEUM 95/143/1
PHOTOS: SUE STAFFORD, PHM

(*Right*) Coat
Spring/summer 1995
Polyester

COLLECTION: KYOTO COSTUME INSTITUTE, AC9214
PHOTO: KAZUMI KURIGAMI, COURTESY KCI

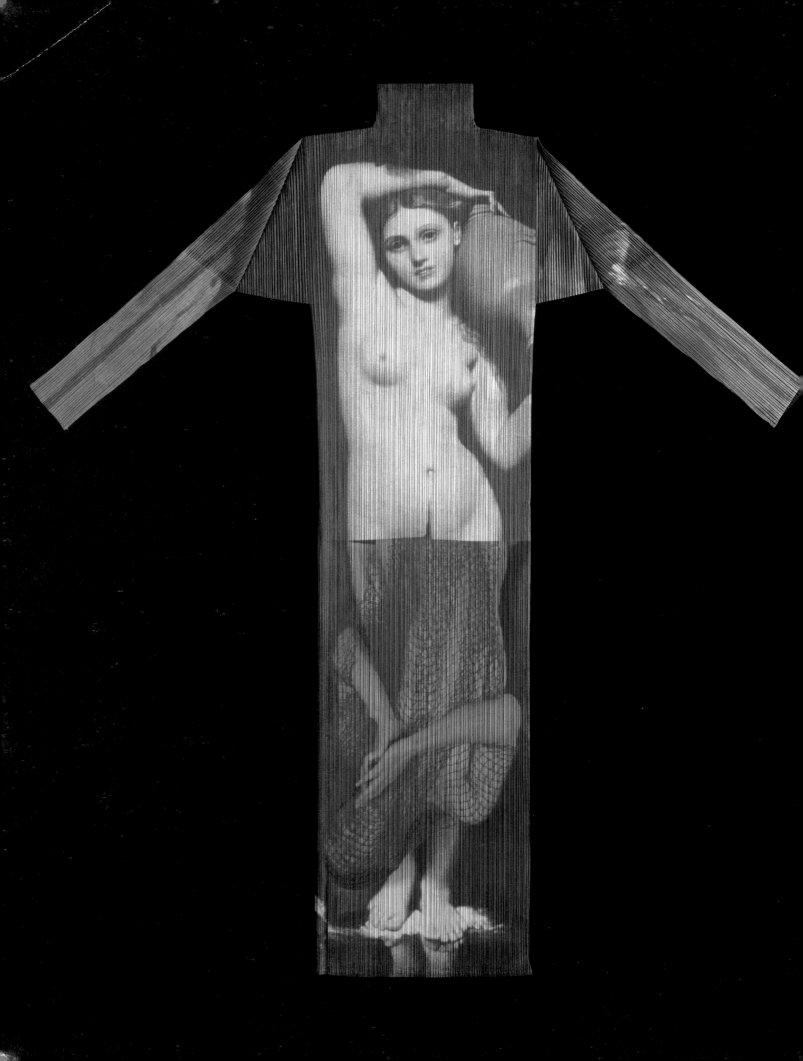

'Pleats Please Issey Miyake Guest Artist' series

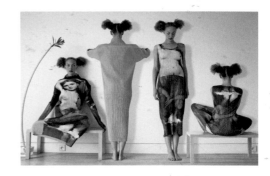

From 1996 to 1998 Issey Miyake invited the four artists Yasumasa Morimura, Nobuyoshi Araki, Tim Hawkinson and Cai Guo Qiang to collaborate with him in the creation of prints for his 'Pleats Please' line of clothing. Miyake's aim with the Guest Artist series was to bring to 'Pleats Please' 'freshness, [a sense of] discovery and renewal within continuity'.[1]

Miyake chose artists who use the body in their own works as a conceptual entity. The first was Yasumasa Morimura (b 1951), who is known for cleverly constructed multimedia images in which he appropriates and transforms painted works which are the basis of historical models of Western art. He often inserts an image of himself into his work, taking on the role of the female subject of a famous painting. In 1996 he and Miyake created a series of five dresses on which Morimura's printed image of his own body fuses with that of the idealised, neo-classical beauty in *La source* by the French 19th century artist Jean-Auguste Ingres. A superimposed, inverted colour-photo image of Morimura, his hands clasped as if in prayer and his head and torso draped in red net, fuses with Ingres' famous beauty. The end result marries disparate images of male and female, the Orient and the West, the naked body with the clothed, in an interplay of historical art and contemporary art and fashion.

1. Interview with Kazuko Sato, 'Freedom clothes, Issey Miyake', *Domus* 798, November 1997, p 106.

(*Opposite*) Dress
Autumn/winter 1996/97
Issey Miyake 'Guest Artist' series
No 1: Yasumasa Morimura for 'Pleats Please'
Screenprinted and pleated polyester

COLLECTION: NATIONAL GALLERY OF AUSTRALIA, 1998.20, GIFT OF ISSEY MIYAKE AND YASUMASA MORIMURA 1997

PHOTO: NATIONAL GALLERY OF AUSTRALIA

(*Top right*) Montage of 'Guest Artist series No 1', 1996

PHOTO: JEAN-MARIE PERIER, AT LARGE, FOR *ELLE FRANCE* 1996

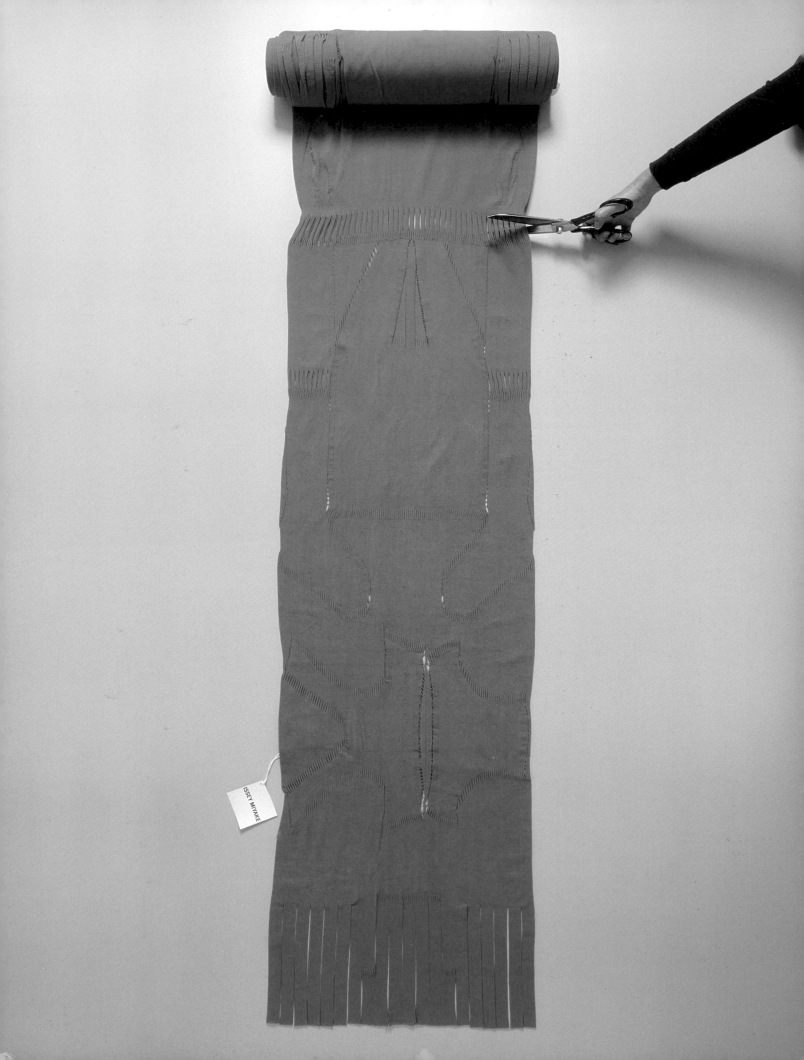

'A-POC'

> I have endeavoured to experiment to make fundamental changes to the system of making clothes. Think: a thread goes into a machine that in turn, generates complete clothing using the latest computer technology and eliminates the usual needs for cutting and sewing the fabric.[1]

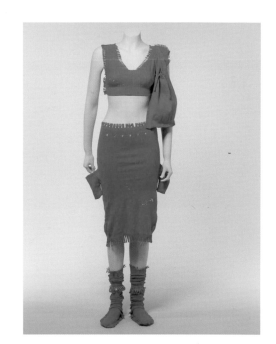

Since establishing MDS in 1970, Issey Miyake has been interested in creating clothes from a single piece of fabric without resorting to Western techniques of tailoring and dressmaking. The development of the 'A-POC' line of clothing, and Miyake's current design focus, is a realisation of his longstanding quest to create wearable and practical clothing from one piece of cloth without waste, cutting and seaming.

A-POC (acronym for 'a piece of cloth' and a play on the word 'epoch') was first shown in 1997. Developed by Miyake and Dai Fujiwara (b 1967), a member of the MDS team who had trained as a textile designer, A-POC is essentially a long tube of machine-knitted patterned fabric that can be cut by the customer to create a whole wardrobe of garments. No sewing is required.

Although knitting in the round without seams is the oldest form of hand knitting and dates back to ancient times, industrially-made seamless knitwear is a relatively new development, pioneered by the makers of lingerie, socks and gloves. In 1965 a Japanese company invented the first machine for manufacturing seamless knitted gloves.[2] A-POC is manufactured using a computer-programmed warp-knitting technology originally used for producing socks. A high-level stretch yarn is used to create a subdivided tube of cloth which, when 'released' by cutting with scissors, opens to form garments. The cutting lines are delineated by gaps where the individual warp threads are not connected to each other.

The customer plays an important role in the creation of an A-POC garment, as each design can be varied according to choice—short or long sleeves, knee or ankle length, round or V neck. In A-POC retail outlets in Tokyo and other cities the customer is encouraged to select and cut their own garment.

1. Issey Miyake, in *Issey Miyake and Dai Fujiwara, A-POC making*, Vitra Design Museum, Weil am Rheim/Germany, 2001, frontispiece.

2. Sandy Black, *Knitwear fashion*, Thames & Hudson, London, 2002, p 118.

(*Opposite*) **A-POC fabric roll**
Spring/summer 1999
Cotton/nylon

(*Top right*) *Queen* **outfit**
Spring/summer 1999
Top, skirt, shirt, bag, socks and hat (not pictured)
Cotton/nylon

(*Right*) **Jumpsuit**
Spring/summer 1999
Cotton/nylon

COLLECTION: POWERHOUSE MUSEUM, 2001/106/4, 106/2, 106/1, GIFT OF PAUL JELLARD 2001

PHOTOS: SUE STAFFORD AND MARINCO KOJDANOVSKI, PHM

HANAE MORI

b 1926, Shimane prefecture

A pioneer of Japanese fashion and revered as a role model for the Japanese working woman, Hanae Mori studied literature at the Tokyo Women's Christian University. After her marriage to Ken Mori, who was involved in the textile industry, she studied fashion design before opening a boutique in Tokyo in 1951. In 1965 Mori presented her first collection overseas, in New York, and in 1977 made fashion history by being the first Japanese person to be accepted into the organisation of French couturiers, the Chambre Syndicale de la Couture Parisienne. Her success, and her position in Japan, was encapsulated in the Hanae Mori building, designed by Kenzo Tange and opened on the Omotesando in Tokyo in 1978

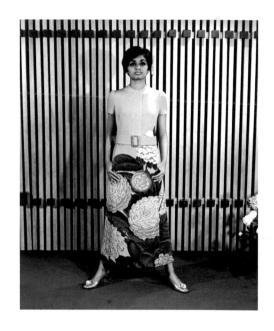

The dress opposite was made in the mid 1960s, around the time Mori established herself, having built up a successful career in Tokyo creating not only fashionable garments for an exclusive clientele but also outfits for the fledgling Japanese film industry. It typifies the sort of restrained, elegant and feminine evening wear Mori became known for. Although it conforms to Western tailoring it is made of luxurious and vibrant *chirimen*, a type of silk crepe with a crimped, matt surface. The fusion of rich, luxurious textiles, often with a distinctly Japanese aesthetic, and Western tailoring, is a hallmark of her designs.

(*Opposite*) Dress (detail)
Autumn/winter 1968/69
Printed silk crepe

COLLECTION: KYOTO COSTUME INSTITUTE, AC8968, GIFT OF MS JUN KANAI

PHOTO: TAKASHI HATAKEYAMA, COURTESY KCI

(*Top right*) Autumn/winter 1968/69 collection.

PHOTO: TAKASHI HATAKEYAMA, COURTESY HANAE MORI HAUTE COUTURE

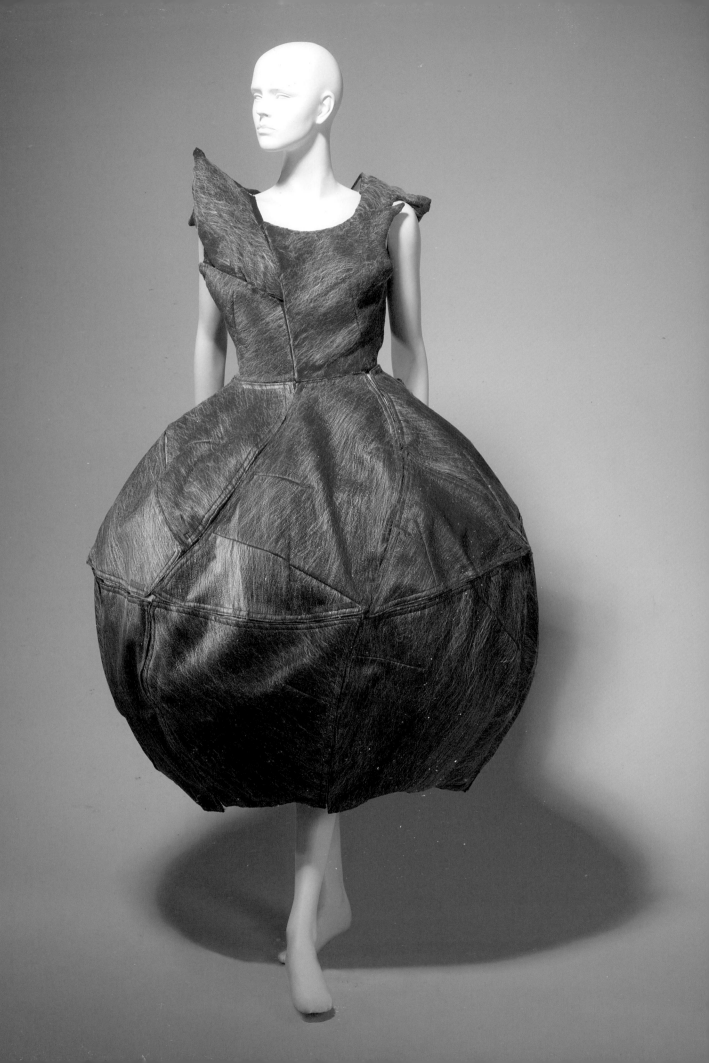

MASAHIRO NAKAGAWA

b 1967, Shiga

Masahiro Nakagawa teamed up with his partner Azechi Lica (b 1967) while at art school in Osaka. They launched the label '20471120' in 1994, and established boutiques in Tokyo and Osaka the following year. They participated in the Tokyo collections for the first time in spring/summer 1995. The 20471120 label (which takes its name from 20 November 2047, the date on which Nakagawa believes 'something wonderful' will happen) is known for its street wear, popular with Tokyo's fashion-conscious youth.

In 1999 Nakagawa's work took on a different focus when he presented a collection with a recycling theme. Nakagawa gathered together clothes with associated meanings that belonged to fashion journalists and art professionals. After interviewing the owners about the memories attached to the garments, Nakagawa and his team set about taking apart and reassembling them. The recycled garments were then given back to their owners. To complement the project, Nakagawa created a number of *manga* characters that provided a storytelling role. Nakagawa says the project grew from his personal response to Tokyo's overwhelming consumer culture and his belief that frugality is the key to tackling Japan's plunging economy. His project critiques fashion and consumerism but he is also seeking to restore a connection between people and their possessions and to give possessions a meaning which he finds lacking in contemporary life.

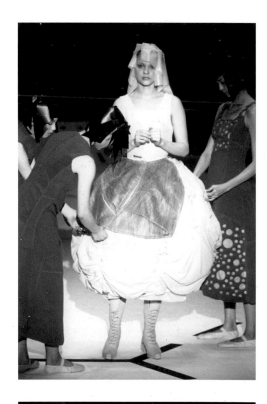

The success of the first 'Recycle' project has led to a series of Recycle projects with different themes. For the fourth Tokyo Recycle project, presented as a millennium collection, 'UNIQLO' garments were used to represent consumerism. UNIQLO is a Japanese manufacturer specialising in the mass production of cheap, functional clothes. In a fashion show these monotonous garments were transformed into a spectacular red dress in 'a dramatic ritual celebrating the birth of a new woman in a new dress made with fragments of the dresses of identical clones, evoking a science fiction scene set in a society governed by a monolithic power'.[1]

The Tokyo Recycle projects have led to participations and collaborations with a number of museums around the world including the Powerhouse Museum in 2005.

1. Midori Matsui, 'Masahiro Nakagawa: doors to a multi-faceted universe', *Nakagawa-Sòchi 20471120*, Little More & Co Ltd, Japan, 2004.

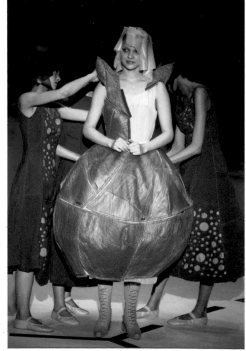

(*Opposite*) **Dress**
Spring/summer 2001
Recycled synthetic

COLLECTION: POWERHOUSE MUSEUM 2005/195/1

PHOTO: SUE STAFFORD, PHM

(*Right*) **Transforming pre-existing UNIQLO brand garments into a 'new' dress, 2000.**
PHOTO: COURTESY MASAHIRO NAKAGAWA

A LONG TIME AGO IN A JEANZ FAR, FAR AWAY.....
OVER THE RAINBOW.

3

4

5

10

11

12

17

18

19

HIROAKI OHYA

b 1970, Kumamoto

Hiroaki Ohya graduated from Tokyo's Bunka College of Fashion in 1992 and went straight to work for the Miyake Design Studio as a designer of accessories. He cites Issey Miyake as the designer who has had the greatest influence on him as he 'learned the spirit to always seek or create something new from him.'[1] After four years at MDS, Ohya set up the studio Oh!ya? Design Zoo Co Ltd in 1996, from which he produces the successful street-wear label 'Astro Boy by Ohya', adopting the 1960s Japanese humanoid cartoon character Astro Boy as his motif.

In the spirit of origami, the traditional Japanese art of paper folding, Ohya's 2000 *Wizard of Jeanz* series of 21 cloth 'books' open up to become clothing. The title of the series is inspired by L Frank Baum's *The Wizard of Oz*, and develops the spirit of Baum's story through the clothes. The first volume transforms into a simple denim shift dress, the second into a printed top, the third into a pair of trousers. Gradually the volumes transform into more elaborate garments, like the accordion-pleated neckpiece in red sailcloth from volume 17. The final volume opens out to be a shift dress in rose printed fabric. The designer has since produced a number of book series with different themes.

'All my ideas come from little doubts that I have in my daily life,' says Ohya.[2] Browsing through a flea market while holidaying in New York, he was impressed with the longevity and permanency of books as objects that can transport ideas. The *Wizard of Jeanz* series came about in part as a reaction to the ephemeral nature and relentless cycle of fashion collections. In line with other Japanese designers, Ohya rejects the notion that fashion needs to beautify the human form: 'Fashion should be more about stories and fantasies that transport us from the daily grind'.[3]

Ohya currently divides his time between working on his own labels and designing for 'Haat', a Miyake label under the directorship of textile designer Mikiko Minagawa.

1. 'Fashion space man', interview in *Metropolis Japan Today* 502, 7 November 2003.
2. Ibid.
3. Notes from the designer.

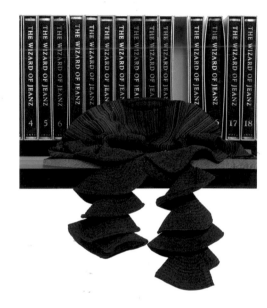

(Opposite) *The Wizard of Jeanz* instructions
Tank top
Printed nylon/cotton

(Above right) *The Wizard of Jeanz*
Spring/summer 2000
21 books (detail)
Printed nylon/cotton

COLLECTION: POWERHOUSE MUSEUM 2005/110/1

PHOTOS: MARINCO KOJDANOVSKI, PHM

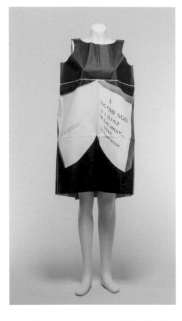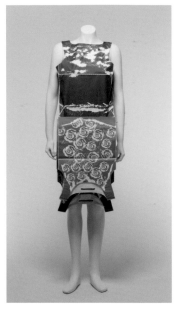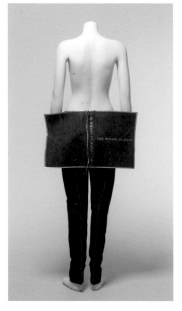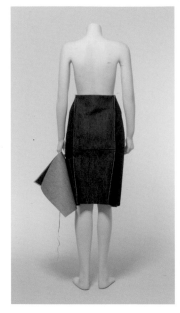

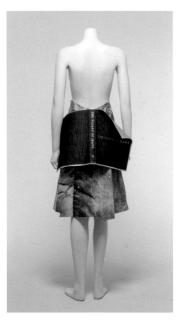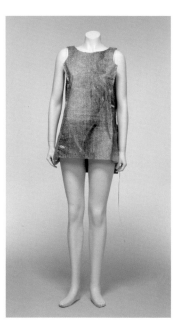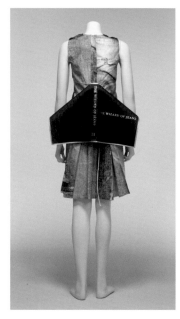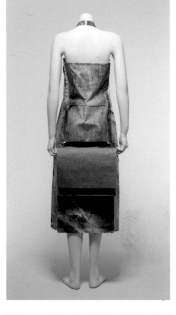

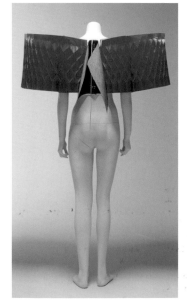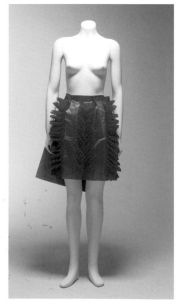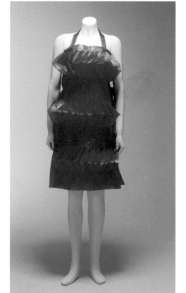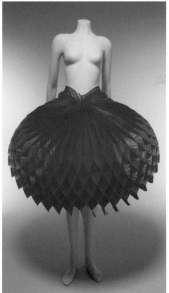

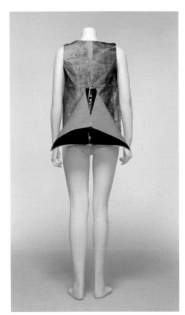
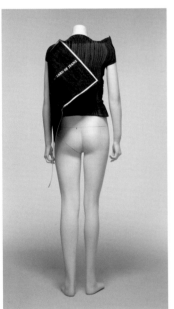
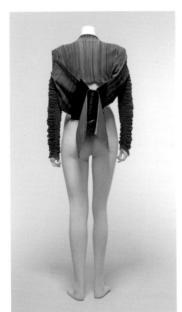
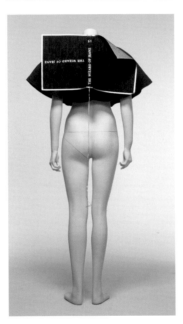
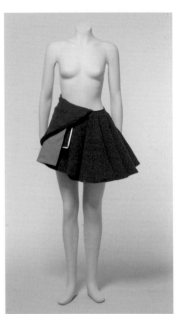
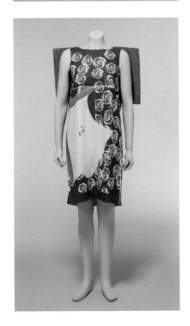

Hiroaki Ohya
The Wizard of Jeanz
Spring/summer 2000
21 books open to garments (*in order 1-21 in three rows from top left*).
Printed nylon/cotton
Ohya's inspiration for the title of the series was L Frank Baum's book *The Wizard of Oz*.

COLLECTION: POWERHOUSE MUSEUM 2005/110/1

PHOTOS: MARINCO KOJDANOVSKI AND SUE STAFFORD, PHM

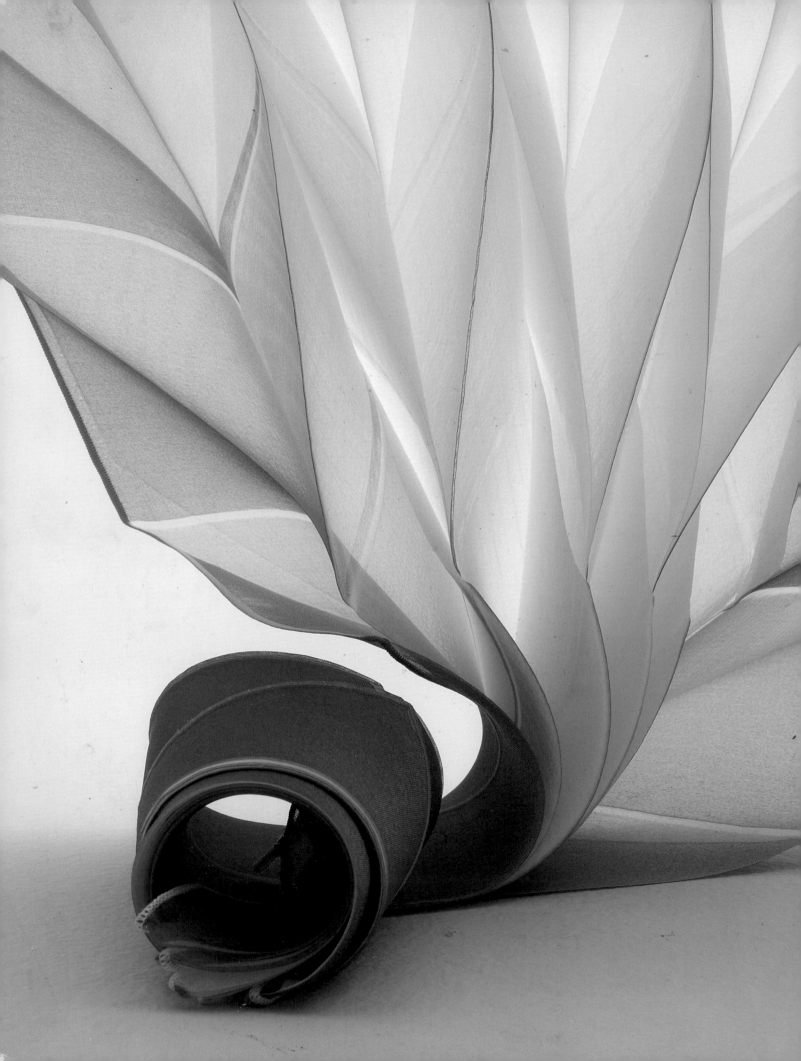

REIKO SUDO

b 1953, Ibaragi

Reiko Sudo graduated from Musashino Art University, Tokyo, in 1975. She worked as a freelance textile designer before co-founding NUNO Corporation with Junichi Arai in 1984. The NUNO Corporation is a Tokyo-based company specialising in the production of innovative textiles. Since Arai withdrew from the business in 1987, Sudo has been sole director. The business has a factory and retail outlet in Tokyo but contracts a network of looms throughout Japan to weave its fabrics.

NUNO (the word means 'cloth') is renowned internationally for the creation of beautiful, functional textiles that link the latest technologies with a reverence for craft traditions. As Sudo explains, 'I take fabrics that, in the past, could only be produced by hand and reinvent them in contemporary ways. I am always exploring industrial means to create things that are seen as traditional, in order to give them a new lease on life in the present.'[1] Although they are industrially produced, characteristic of NUNO fabrics is the intervention of manual processes.

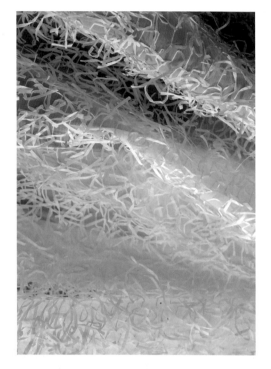

The *Patched paper* (*Yaburegami*) textile (illustrated right) was created using the unlikely combination of polyester and *minowashi* paper.[2] After weaving the slit yarns of this paper for wefts with the polyester warp threads on a computer-assisted Jacquard loom, the paper yarns were cut by hand to give the textile's surface a random quality.

The interesting surface pattern of the *Tsugihagi* textile (below right) was created by using chemicals on a cloth made from a variety of remnant NUNO fabrics carefully cut into squares, laid out neatly to cover the surface, and stitched down by sewing machine. Dissolving the base fabric in water leaves a piecework of swatches over a lacy background, described by NUNO as a 'serendipitous survey of NUNO originals of different patterns, colours and materials all in one cloth'. The *Origami pleat* textile (left) was treated with a combination of hand-pleating and dyeing before being permanently heat-set by a machine.

1. Quoted in Yoshiko Iwamoto Wada, *Memory on cloth: shibori now*, Kodansha, Tokyo, 2002, p 60.
2. A traditional handmade paper from the Mino region near Gifu in the mountains of Honshu. The paper is very strong and is used for shoji (paper sliding doors).

(Opposite) Origami pleat
Directed by Reiko Sudo, 1997
Technique developed by Mizue Okada; hand-pleating by Hioraki Takekura and Hiroko Suwa
Polyester
Hand-pleated and heat-set with paper transfer dye, 44 cm x 150 cm

COLLECTION: POWERHOUSE MUSEUM 2005/196/2, GIFT OF NUNO CORPORATION 2005
PHOTO: PHOTO: SOTHA BOURN, PHM

(Top right) Patched paper (Yaburegami)
Designed by Reiko Sudo, 1997
Polyester 43%, paper 57%, Jacquard weave, 112 cm wide

COLLECTION: POWERHOUSE MUSEUM 2005/196/4, GIFT OF NUNO CORPORATION 2005
PHOTO: SUE MCNAB, COURTESY NUNO CORPORATION

(Right) Tsugihagi (Basho)
Designed by Reiko Sudo and Kazuhiro Ueno, 1997
Various fabrics
Chemical lacework, 80 cm wide

COLLECTION: POWERHOUSE MUSEUM 2005/196/5, GIFT OF NUNO CORPORATION 2005
PHOTO: SOTHA BOURN, PHM

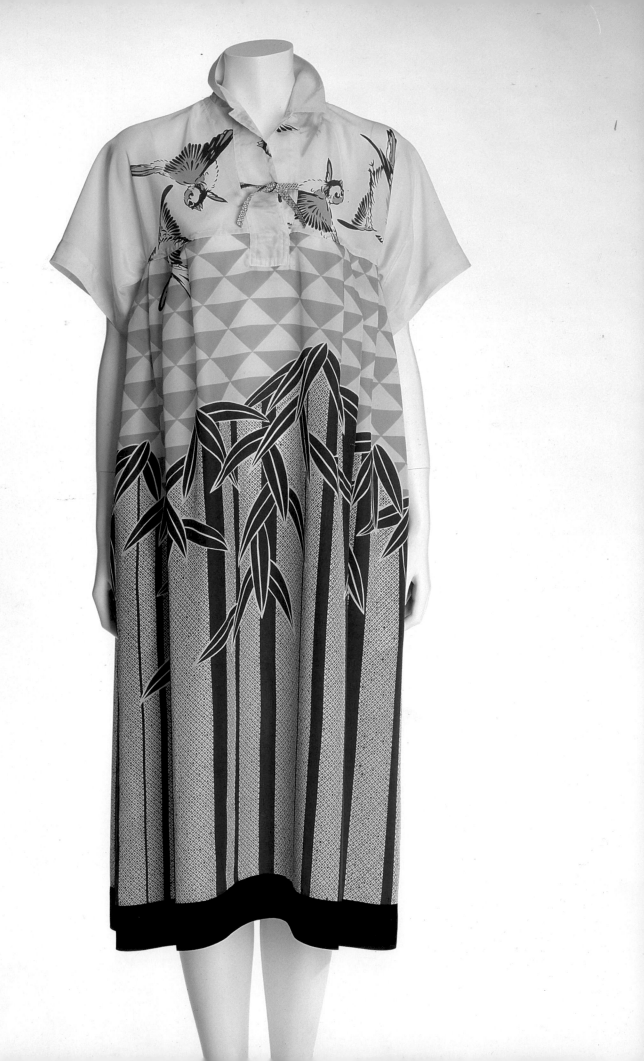

KENZO TAKADA

b 1939, Kyoto

Kenzo Takada was the first Japanese fashion designer to show his work in Paris, in 1970, and the success of his collections encouraged other Japanese designers to follow. Kenzo (as he was known) studied fashion at the Bunka College of Fashion in Tokyo and first worked as a pattern designer in Tokyo. In Paris he initially supported himself by selling designs to Louis Féraud, fashion department stores and magazines. In 1970 he opened the boutique Jungle Jap, selling his own line of ready-to-wear clothes.

Kenzo's clothes were typically loose cut, possessed youthful styling and were brightly coloured. He designed within the parameters of the Western clothing tradition but liked to incorporate aspects of worldwide regional dress. Collections produced during the 1970s showed the influence of a diverse range of influences, including African and Japanese textile patterns, Chinese work-wear, Portuguese regional dress, American popular culture, Javanese batiks, European peasant smocks and aprons. The simple dress pictured opposite, designed in 1970, is loose fitting with kimono-cut sleeves. With its printed Japanese-style pattern, the dress is characteristic of Kenzo's relaxed, loose-fitting garments incorporating elements of regional dress.

Kenzo retired in 1999 and the label, owned by the French company LVMH, is currently designed by Sardinian-based Antonio Marras.

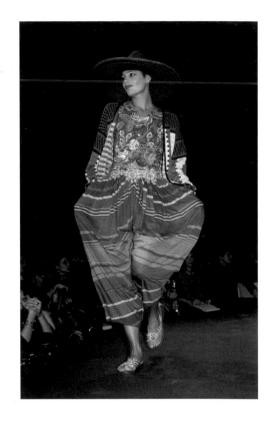

(*Opposite*) **Dress**
1970
Acetate printed with bamboo and sparrow motifs

COLLECTION: KYOTO COSTUME INSTITUTE AC8989, GIFT OF MS SUMIYO KOYAMA

PHOTO: YASUSHI ICHIKAWA, COURTESY KCI

(*Top right*) **Inspiration from Mexican regional dress influenced Kenzo's
spring/summer 1984 collection.**

PHOTO: COURTESY APL/CORBIS

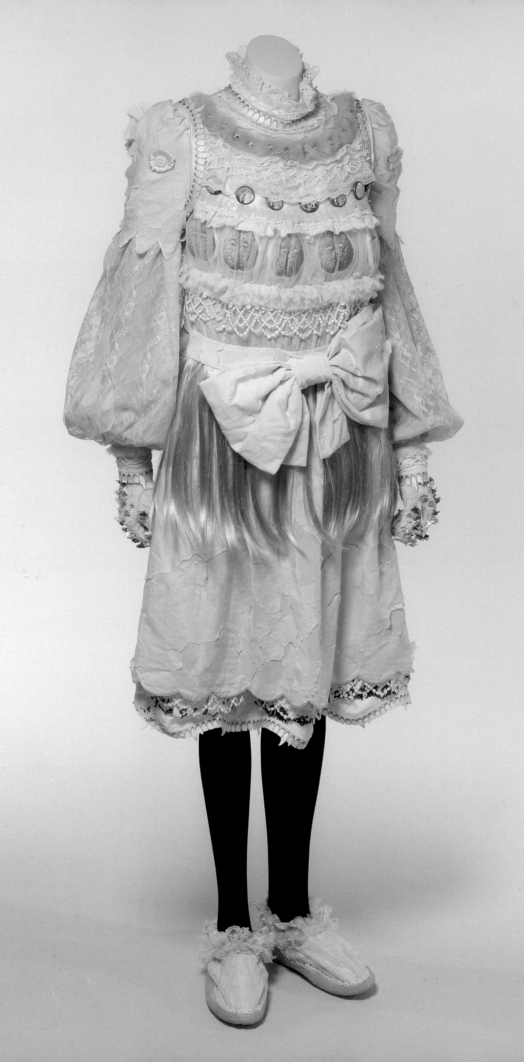

JUN TAKAHASHI

b 1969, Kiryu prefecture

While still at Bunka College of Fashion in Tokyo, Jun Takahashi launched his T-shirt label 'Nowhere' with his friend Nigo (who later went on to develop the cult Japanese street-wear label 'A Bathing Ape'). After graduation, Takahashi had a brief career as a singer in the Punk band Tokyo Sex Pistols, before creating his highly successful label 'Undercover', in 1994. Undercover is a cult label in *ura Harajuku* (the back streets of Harajuku, Tokyo, the centre of the Japanese fashion subculture). In 2002—under the aegis of Rei Kawakubo—he debuted his label in Paris.

For his spring/summer 2005 collection, Jun Takahashi paid homage to Czech visual artist Jan Svankmajer and his film *Alice* (1988), an eerie, surreal interpretation of Lewis Carroll's *Alice's Adventures in Wonderland*. Alice inhabits a nightmarish world of rotting furniture, stuffed animal corpses and malevolent antique dolls. Taking his cue from the film's decaying domestic environment, Takahashi created Edwardian-style dresses in lace, silk and tulle, layered and meticulously ripped and sewn and then cut to appear cracked and rotting, with details such as embroidered trims that look like teeth and buttons shaped like eyeballs.

Detail, layering and eclectic use of colour and pattern are characteristic of the work of Takahashi, who says that his signature designs lie between high fashion and street wear.

(*Opposite*) Women's outfit
'but beautiful II homage to Jan Svankmajer'
Spring/summer 2005
Dress, tights, shoes, gloves and hat (not pictured)
Polyester, cotton, nylon, rubber
Label: Undercover Jun Takahashi

COLLECTION: POWERHOUSE MUSEUM 2005/112/1

PHOTO: MARINCO KOJDANOVSKI, PHM

(*Top right*) Women's outfit
'Melting Pot'
Autumn/winter 2000/01
Jacket, jumper, skirt, pants, scarf, belt, bag, gloves, stockings and wig
Wool, mohair, synthetic leather
Label: Undercover Jun Takahashi

COLLECTION: KYOTO COSTUME INSTITUTE AC10377

PHOTO: TAKASHI HATAKEYAMA, COURTESY KCI

(*Right*) Undercover's 'but beautiful II homage to Jan Svankmajer' spring/summer 2005 collection parade.

PHOTO: COURTESY OF UNDERCOVER

NAOKI TAKIZAWA

b 1960, Tokyo

Naoki Takizawa graduated from the Kuwasawa Design Institute in 1982 and immediately joined the Miyake Design Studio (MDS) initially working as a designer for the 'Miyake Plantation' label, a range that used natural fibres and emphasised comfort and affordability. He became part of a team at MDS involved in the development of innovative fabric and manufacturing techniques. He was made the official designer for 'Issey Miyake' menswear in 1993. When Miyake decided to devote himself to his 'A-POC' line in 1999, he handed over the role of designer of Issey Miyake to Takizawa. (Miyake remains general creative director at MDS.) The line is now called 'Issey Miyake by Naoki Takizawa'.

Although less obviously experimental than Miyake, Takizawa challenges prevailing fashion conventions and his clothes remain influenced by MDS's longstanding commitment to design that promotes freedom of movement. Like many of his Japanese counterparts he avoids rigid tailoring. His catwalk presentations are noted for their theatrical flair. *Journey to the moon* was the theme for his autumn/winter 2004/05 collection, in which Takizawa collaborated with Aya Takano (b 1976), a Japanese artist whose work has an affinity with Pop art, science fiction and *anime*. The collection's signature pieces were garments made from circles of silk and screen-printed with Takano's images, which wrapped around the body to form long dresses and skirts.

(*Opposite*) Dress, part of women's outfit
Issey Miyake by Naoki Takizawa
Autumn/winter 2004/05
Silk
Screen-printed design by Aya Takano
COLLECTION: KYOTO COSTUME INSTITUTE, GIFT OF MIYAKE DESIGN STUDIO
PHOTO: YASUSHI ICHIKAWA, COURTESY KCI

(*Right*) Issey Miyake by Naoki Takizawa, autumn/winter 2004/05 collection parade.
PHOTO: COURTESY AUSTRAL

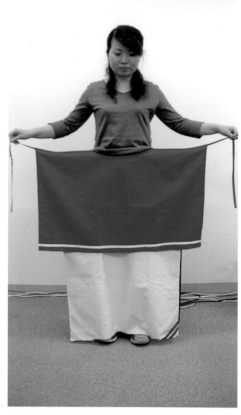
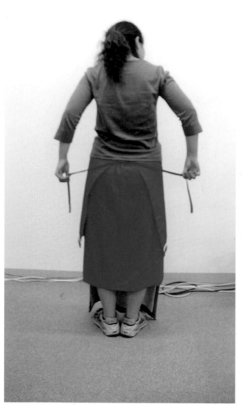
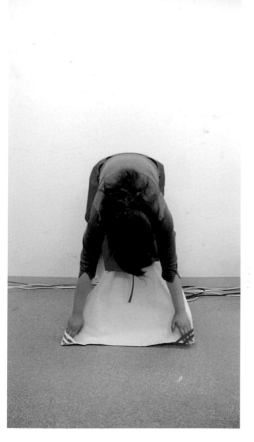
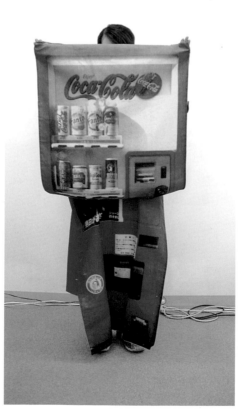
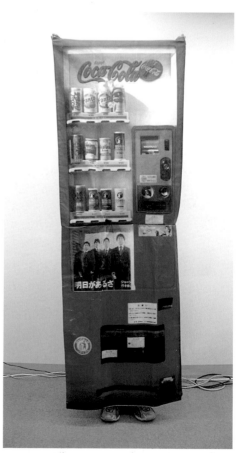

AYA TSUKIOKA

b 1978, Ehime prefecture

When Aya Tsukioka was studying fashion design at the Musashino Art University, she collaborated in a group project with the theme of 'shelter'. Tsukioka's interpretation of 'shelter' was 'a place to hide', and she developed a double-layered wrap skirt with a life-size image of a vending machine screen-printed on the reverse of the front panel. When the wearer wants to seek shelter, she unwraps the skirt's top layer and lifts it up to reveal the image. Tsukioka's idea of shelter was not a military image of protecting one's body so much as a place from which to escape momentarily from everyday life.

There are millions of vending machines throughout Japan. Wearers of the *Instant vending machine* skirt can transform themselves into a vending machine wherever and whenever they like. The wearable skirt is camouflage for modern living. The designer's stated aim is to provoke laughter by creating clothes that encourage us to recognise the need for moments of respite.

The *Instant vending machine* skirt was the first in a series of hide-and-seek garments that Tsukioka continues to work on in an ongoing project she has titled 'A new hide and seek strategy'. Other garments include a large tote bag in the shape of a porthole and a rucksack that transforms to look like a fire extinguisher (also see p11). Her work has been displayed in solo and group exhibitions in Japan.

(*Opposite*) From skirt to vending machine—a model demonstrates the transformation of a wearable synthetic and cotton wrap skirt. The skirt is double-layered with an image of a full-size vending machine screenprinted on the reverse of the front panel.

(*Right*) *Instant vending machine* out and about—vending machines are ubiquitous in Japan offering the wearer the opportunity to transform wherever and whenever they like.

PHOTOS: COURTESY AYA TSUKIOKA

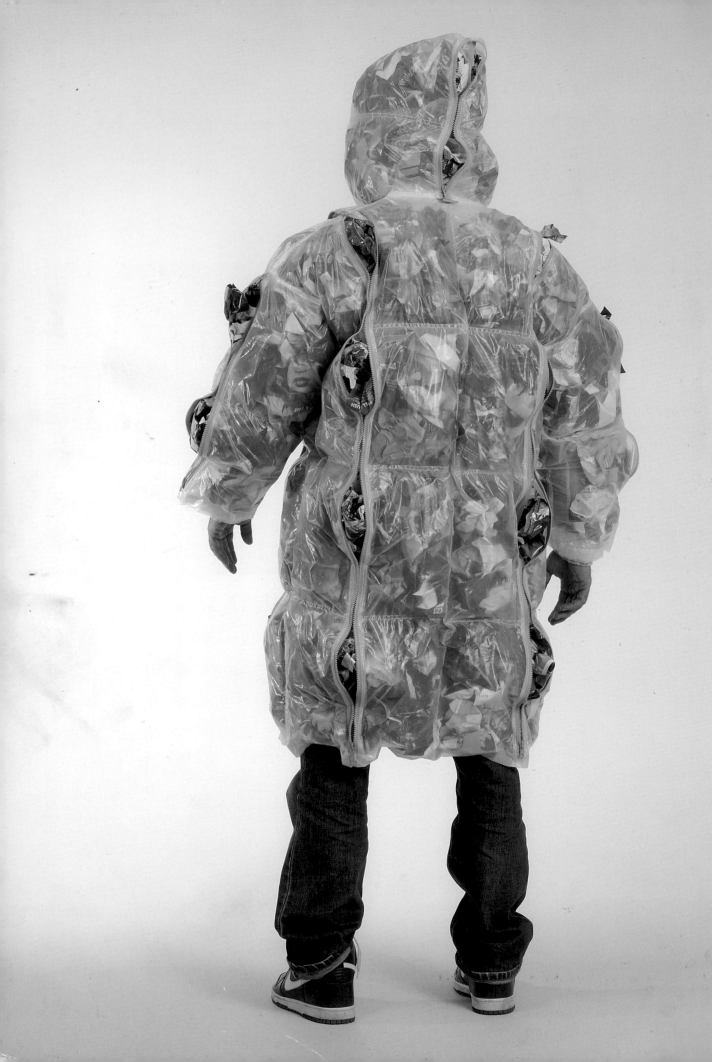

KOSUKE TSUMURA

b 1959, Saitama

If we lose our house because of a disaster, war or unemployment, as a fashion designer, what kind of clothes would I propose—and how would they look in trouble-free times? www.finalhome.com

Kosuke Tsumura joined the Miyake Design Studio in 1983. In 1993 he launched his 'FINAL HOME' label, which evolved from Issey Miyake Inc (now A-net Inc).

Since 1994 the signature piece of the FINAL HOME label has been a transparent nylon coat with up to 40 multifunction zip pockets. After developing a prototype, Tsumura himself spent several nights sleeping outdoors on city streets trialling the warmth and comfort of his coat, which he conceived as a final home in the case of a natural or man-made disaster. Tsumura describes it as 'a cloth which can be adapted according to need'. For protection against the cold, for example, the wearer can stuff newspapers into the pockets; one can equip the coat with survival rations and a medical kit, or even with soft toys to comfort children during a catastrophe.

The FINAL HOME label promotes concepts of protection, functionalism and recycleability. The simplicity of Tsumura's designs, coupled with their jokey super-functionality, has made FINAL HOME a top choice amongst the young in Japan. Other FINAL HOME creations include a poncho which doubles as a bicycle cover, a *momoko* doll, cardboard sofas, 'pocket' sofa covers and chocolate candles all designed to aid survival in various conditions.

The FINAL HOME company supports organisations that aid refugees and disaster victims. In addition, Tsumura has experimented with FINAL HOME products to create installations for numerous art exhibitions, including the Venice Biennale 2000 and the Shanghai Biennale in 2002.

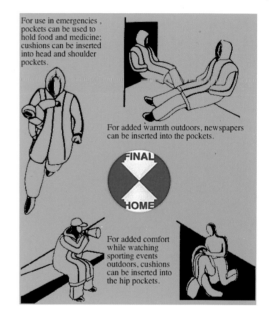

(*Opposite*) Multi-pocket coat
2005
Nylon with zipper; stuffed with packaging, newspapers and magazines sourced locally
Label: FINAL HOME

COLLECTION: POWERHOUSE MUSEUM 2005/115/1

PHOTO: MARINCO KODJANOVSKI, PHM

(*Right*) FINAL HOME instructions
FINAL HOME'S website provides detailed information on how to use the jacket.

FINAL HOME http://parallel.park.org/Japan/DNP/MTN/KT/FINALPROj/history/

JUNYA WATANABE

b 1961, Tokyo

Techno textiles

Junya Watanabe is the most celebrated of the younger generation of Japanese designers, acknowledged as a major avant-garde figure in international fashion. In 1984 Watanabe entered Comme des Garçons, the clothing company established by Rei Kawakubo. He was responsible for the design of the company's 'Tricot' label, a knitwear line sold mostly in Japan, before the Junya Watanabe Comme des Garçons collection was introduced in Paris in 1993 with the financial support of his mentor Rei Kawakubo. He introduced his menswear line in collaboration with Levi's in 2001.

Like Kawakubo, Watanabe is interested in innovative textiles and construction techniques. The first collection to bring him international acclaim appeared in 1995. He showed slim-line knee-length tunics and pantsuits made from a polyurethane laminated nylon in bright colours inspired by the gels used in theatre lighting. Although the garments have simple silhouettes, the construction is visibly complex, with folds, tucks and pleats emphasised at the joints of the body to make the outfits more comfortable.

Watanabe's interest in the development of textiles led to a collaboration with the Japanese textile company Toray, which specialises in technologically advanced textiles for extreme conditions. The Toray-developed microfibre fabric was used in Watanabe's spring/summer 2000 collection. The lightweight, water-resistant synthetic can 'breathe' and is more comfortable to wear than waterproof fabric. For the collection's catwalk presentations, models gambolled under a manufactured downpour to Karen Carpenter singing 'Rainy days on Monday' (also see p 9).

(*Opposite and right*) Dress and detail
Junya Watanabe Comme des Garçons
Autumn/winter 1995/96
Synthetic

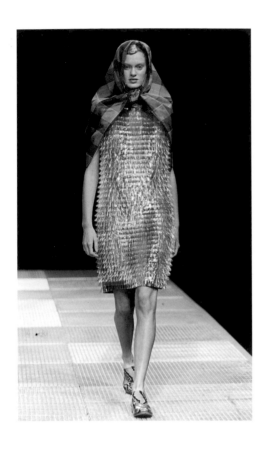

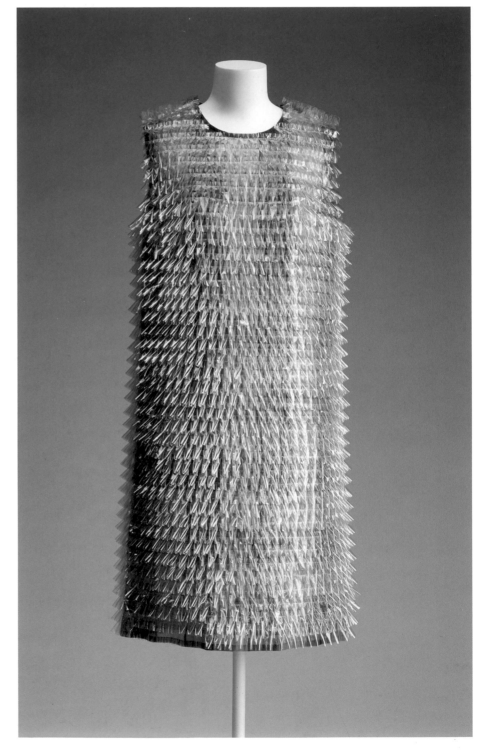

(*Right*) Dress
Junya Watanabe Comme des Garçons
Spring/summer 2000
Plaid orange polyester with plastic overlay

COLLECTION: KYOTO COSTUME INSTITUTE AC10284

PHOTO: TAKASHI HATAKEYAMA, COURTESY KCI

(*Above*) **Junya Watanabe Comme des Garçons spring/**
summer 2000 collection parade

PHOTO: JEAN FRANÇOIS JOSÉ, COURTESY OF COMME DES GARÇONS

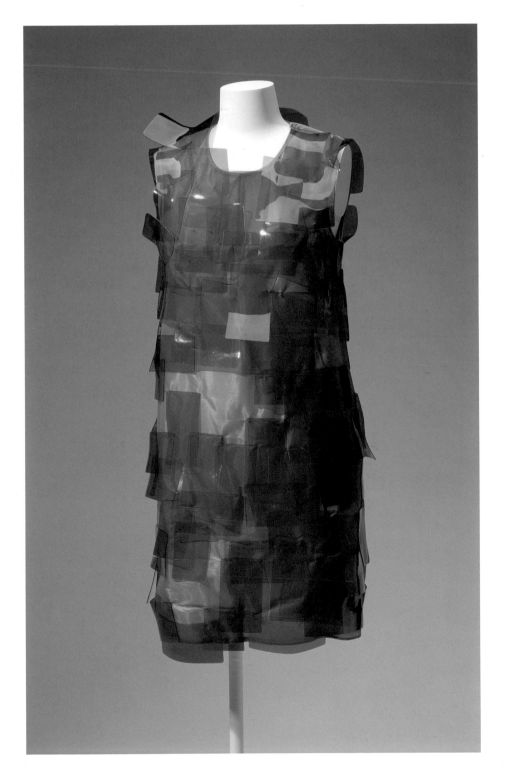

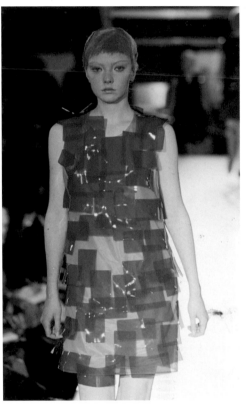

(*Left*) Dress
'Digital Modern Lighting for the Future'
Spring/summer 2001
Nylon/polyurethane acrylic pieces

COLLECTION: KYOTO COSTUME INSTITUTE AC10440

PHOTO: TAKASHI HATAKEYAMA, COURTESY KCI

(*Above*) Junya Watanabe Comme des Garçons spring/
summer 2001, parade

PHOTO: JEAN FRANÇOIS JOSÉ, COURTESY OF COMME DES GARÇONS

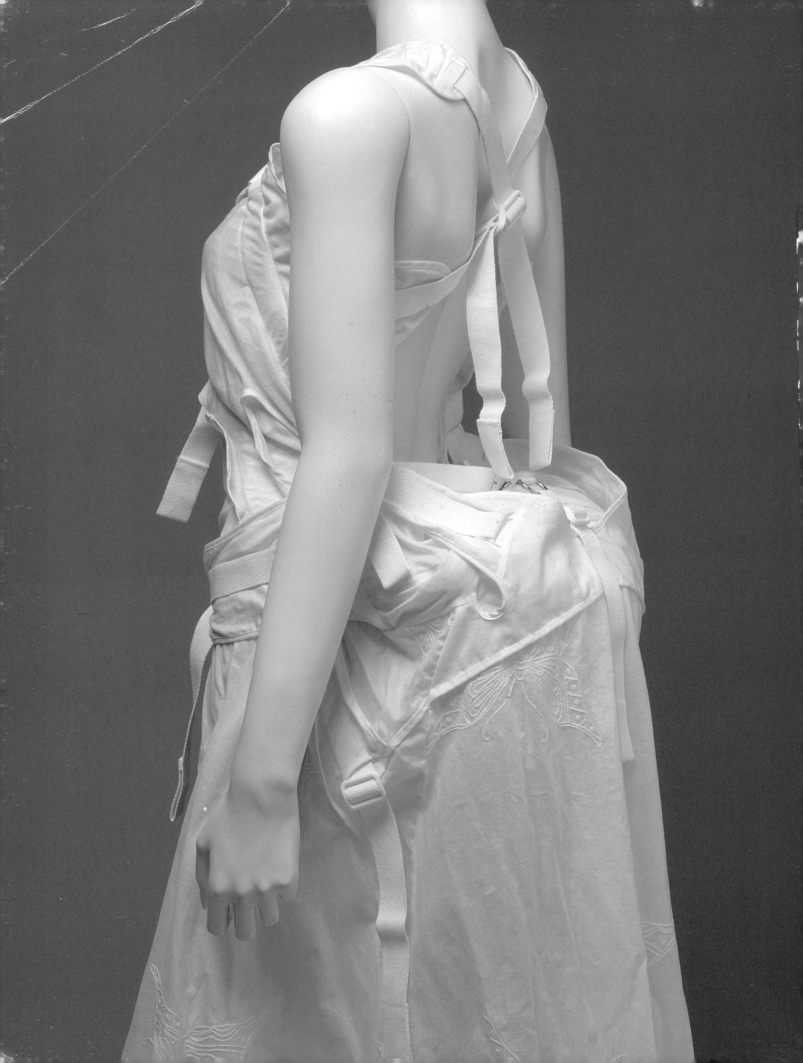

Recent collections

Junya Watanabe launched the 'Junya Watanabe Comme des Garçons' label in 1992 and has shown in Paris since 1993. Like Rei Kawakubo ('Rei has taught me everything about how to create'[1]), with each collection he strives to create something new and distinctive.

Along with a preference for technologically advanced fabrics, Watanabe's designs for his women's wear collections are typically feminine, provocative in a playful manner and display technical inventiveness. In his autumn/winter 2000/01 collection, opulent evening dresses with a 'futuristic' appearance were created with polyester organdie sewn layer upon layer in a honeycomb pattern so that it fanned out, origami like, and could fold flat (see p 101).

Watanabe's designs also reference historical dress. The wool skirt, stretched taut and extended with wire, from his autumn/winter 1998/99 collection (pictured right) is reminiscent of the wide-hipped silhouette of the formal 18th century gown achieved by the use of the pannier, but can also be a reference to the abstractions of 20th century constructivism. The pannier, or the late 19th-century bustle, is a citation for a dress in Watanabe's spring/ summer 2003 collection (pictured left), in which the designer's distinctive inventiveness fused a backpack into a backless summer dress.

1. *i.D*, no 195, March 2000, p 244.

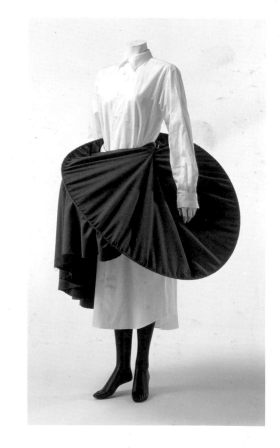

(*Opposite*) Dress
Junya Watanabe Comme des Garçons
Spring/summer 2003
Cotton

COLLECTION: POWERHOUSE MUSEUM 2004/17/1
PHOTO: SOTHA BOURN, PHM

(*Right*) Shirt dress with hooped skirt
Junya Watanabe Comme des Garçons
Autumn/winter 1998/99
Cotton shirt, wool skirt with wire hoop

COLLECTION: KYOTO COSTUME INSTITUTE AC9689
PHOTO: TAKASHI HATAKEYAMA, COURTESY KCI

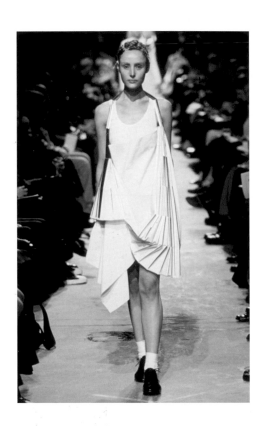

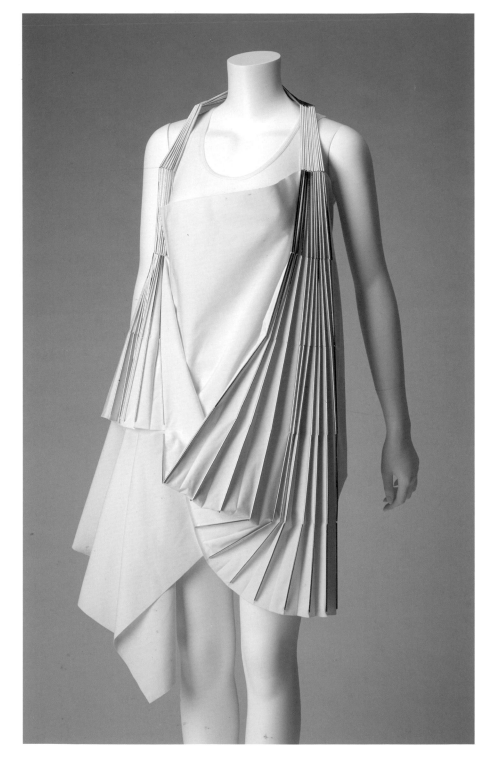

(*Right*) Dress
Junya Watanabe Comme des Garçons spring/summer
1999
Polyester/cotton with metal rods

COLLECTION: KYOTO COSTUME INSTITUTE AC9762

PHOTO: TAKASHI HATAKEYAMA, COURTESY KCI

(*Above*) Junya Watanabe Comme des Garçons spring/
summer 1999 collection parade.

PHOTO: JEAN FRANÇOIS JOSÉ, COURTESY OF COMME DES GARÇONS

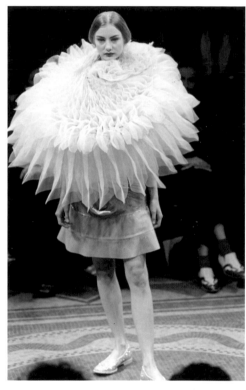

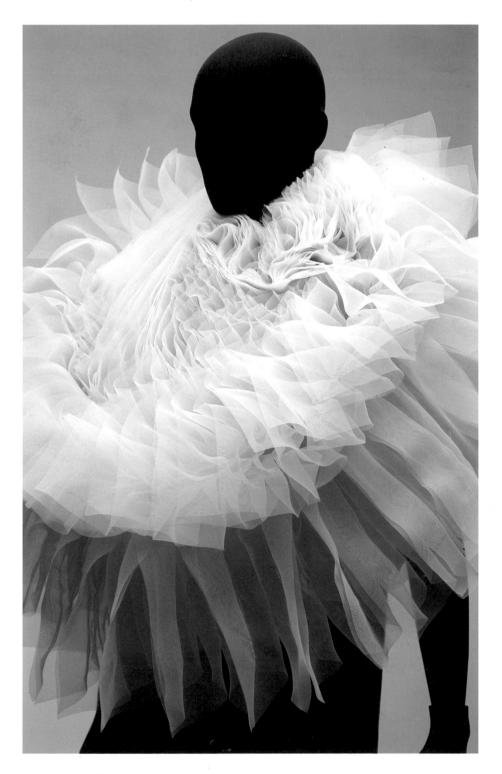

(*Left*) Neckruff
Junya Watanabe Comme des Garçons
Autumn/winter 2000/01
Polyester organdie

COLLECTION: KYOTO COSTUME INSTITUTE AC10361
PHOTO: TAISHI HIROKAWA, COURTESY KCI

(*Above*) Junya Watanabe Comme des Garçon autumn/
winter 2000/01 collection parade.

PHOTO: JEAN FRANCOIS JOSÉ, COURTESY COMME DES GARÇONS

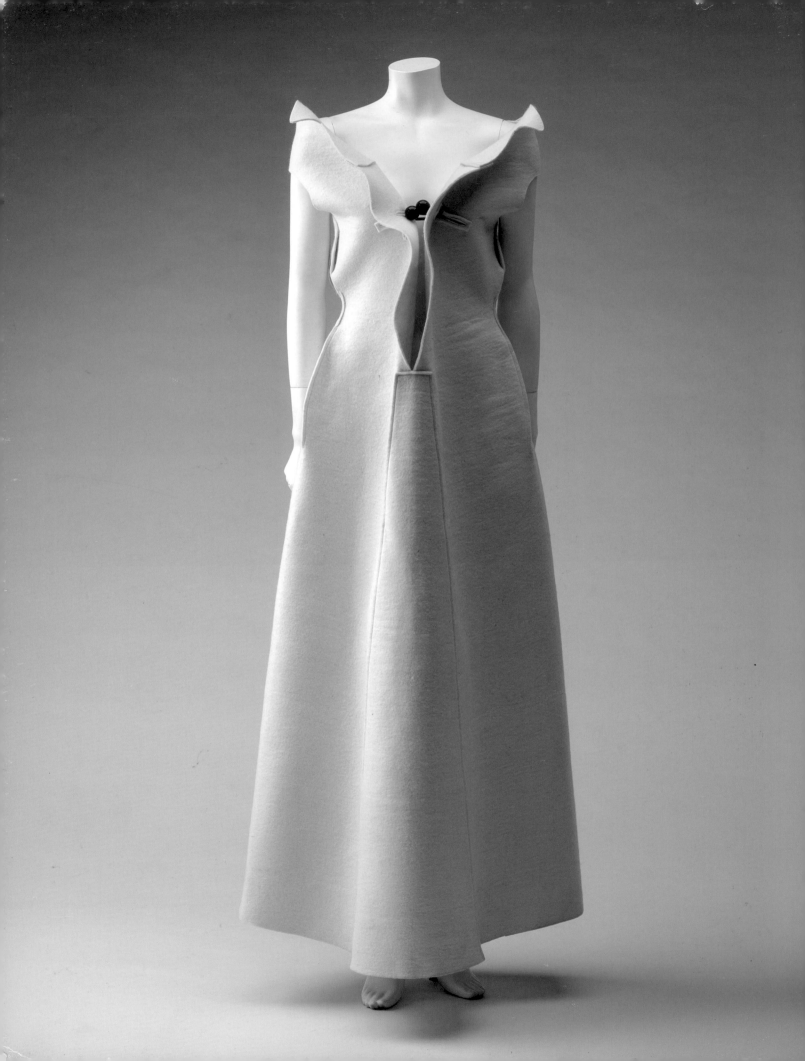

YOHJI YAMAMOTO

b 1943, Tokyo

Anti–fashion

> I want to achieve anti fashion through fashion. That's why I'm always heading in
> my own direction, in parallel to fashion. Because if you're not waking up what is
> asleep, you might as well stay on the beaten path.[1]

> My most important concern about fashion is still about breaking some code,
> some tendency, which I do by using fashion.[2]

Yohji Yamamoto is a leading designer who, since 1981, has maintained a creative
stronghold in his home country as well as internationally. The son of a seamstress,
Yamamoto initially trained as a lawyer, then studied at the Bunka College of Fashion. After
graduating he worked for his mother before setting up as a designer in the late 1960s and
establishing his own label in 1971. He held his first show in Tokyo in 1977.

Successful in Japan, Yamamoto teamed up with Rei Kawakubo to launch his label in Paris
in 1981, the two designers sharing a parallel vision in the early 1980s. In contrast to the
embellished and structured clothing in vogue at the time, their 'anti-fashion' designs were
oversized, layered and monochromatic. Yamamoto advocated asymmetry and eschewed
conventional forms of decoration such as embroidery or printed pattern, often introducing
cut-outs, non-functional flaps, and irregular hems and collars as points of interest. He took
to adding labels to his garments that read, 'There is nothing so boring as a neat and tidy
look'.

Alongside his experimental 'Yohji Yamamoto' label, however, Yamamoto has introduced
more affordable, and wearable, lines under the labels 'Y's For Men' and 'Y's For Women'.

In the second half of the 1980s Yamamoto gradually introduced a structured silhouette,
and since then his collections have been characterised by romantic, avant-garde clothes
more in tune with Western aesthetics. Yamamoto is celebrated for his superb tailoring
creating flattering suits, mostly in black, for both men and women. His clothes often have a
sculptural quality and he likes to combine unusual materials (illustrated is an evening dress
made of felt) and to juxtapose modern with traditional elements. His recent collections have
paid homage to postwar Paris couturiers by creating clothes that reference couture but
remain true to his distinctive modernist aesthetic.

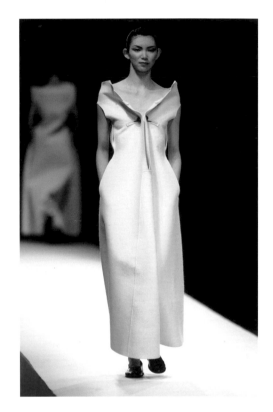

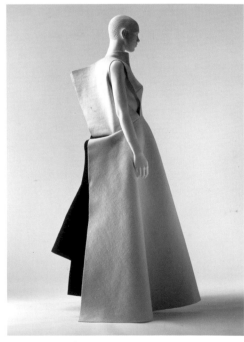

(*Opposite*) Dress
Autumn/winter 1996/97
Felt

COLLECTION: KYOTO COSTUME INSTITUTE AC9327

PHOTO: TAKASHI HATAKEYAMA, COURTESY KCI

(*Top right*) Autumn/winter 1996/97 collection parade

PHOTO: COURTESY FIRSTVIEW

(*Right*) Dress
Autumn/winter 1996/97
Felt with knitted wool undershirt

COLLECTION: KYOTO COSTUME INSTITUTE AC9328

PHOTO: TAKASHI HATAKEYAMA, COURTESY KCI

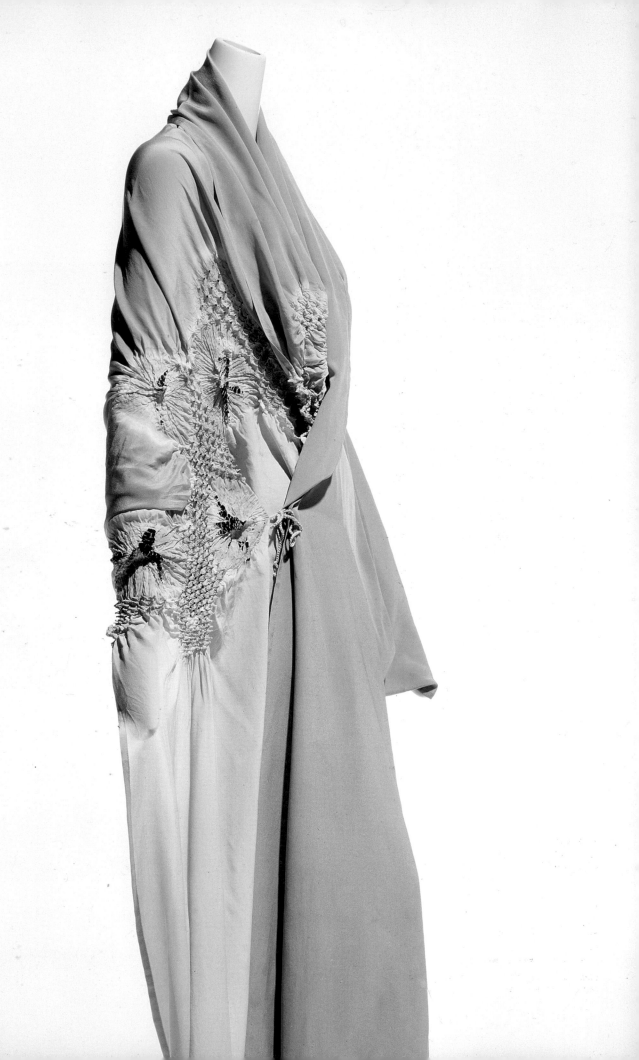

Revisiting Japanese traditions

As much influenced by the history of Western fashion as by his Japanese background, Yohji Yamamoto also refers to traditions in international clothing and textiles in his designs. For example, he used the wide skirts of Russian dolls for his autumn/winter 1990/91 collection, the textures of Thai and African fabrics for his spring/summer 1993 collection, and created fur-lined clothing inspired by Inuit dress for autumn/winter 2000/01.

In spring/summer 1995 Yamamoto presented a collection that had an overtly Japanese aesthetic, 'a reinterpretation of traditional Japanese clothing in all its majesty and its secret act of seduction'.[3] The collection included garments that took their inspiration from the kimono, the traditional dress of Japan. The black jersey dress (right) crosses at the front and ties at the back, causing the side of the dress to swell in a contemporary interpretation of the kimono sash or *obi*. The brocaded silk of the skirt features a pattern of roundels with stylised chrysanthemum motifs—an emblem of Japan.

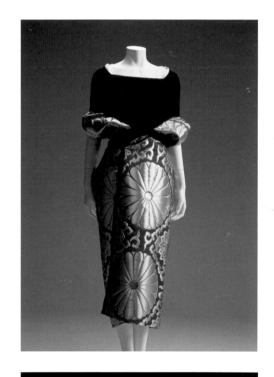

Like a kimono, the one-piece silk crepe de chine coat-dress is cut straight and wraps loosely around the body. The elegance of the garment is enhanced with a pattern created by using the technique of *shibori* (usually translated as tie-dyeing), which involves the binding and stitching of the fabric prior to immersion in the dye. The colour doesn't penetrate the areas protected in this way. To create the distinctive puckered pattern seen in the coat-dress (pictured left), small portions of the cloth were pinched and bound with thread before dyeing. Where the tips of each tiny section of cloth were left unbound, a small dot of colour appears in the centre of the protected areas.

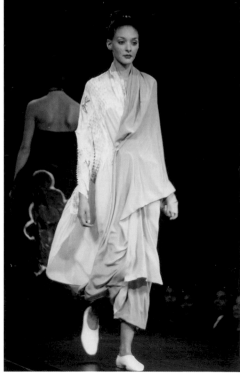

(*Opposite*) Coat-dress
Spring/summer 1995
Silk patterned by shibori dyeing technique
COLLECTION: KYOTO COSTUME INSTITUTE AC9157
PHOTO: TAKASHI HATAKEYAMA, COURTESY KCI

(*Above right*) Dress
Spring/summer 1995
Brocaded silk/rayon jersey and synthetic brocade
COLLECTION: KYOTO COSTUME INSTITUTE AC9166
PHOTO: TAKASHI HATAKEYAMA, COURTESY KCI

(*Right*) Spring/summer 1995 collection parade
PHOTO: COURTESY APL/CORBIS

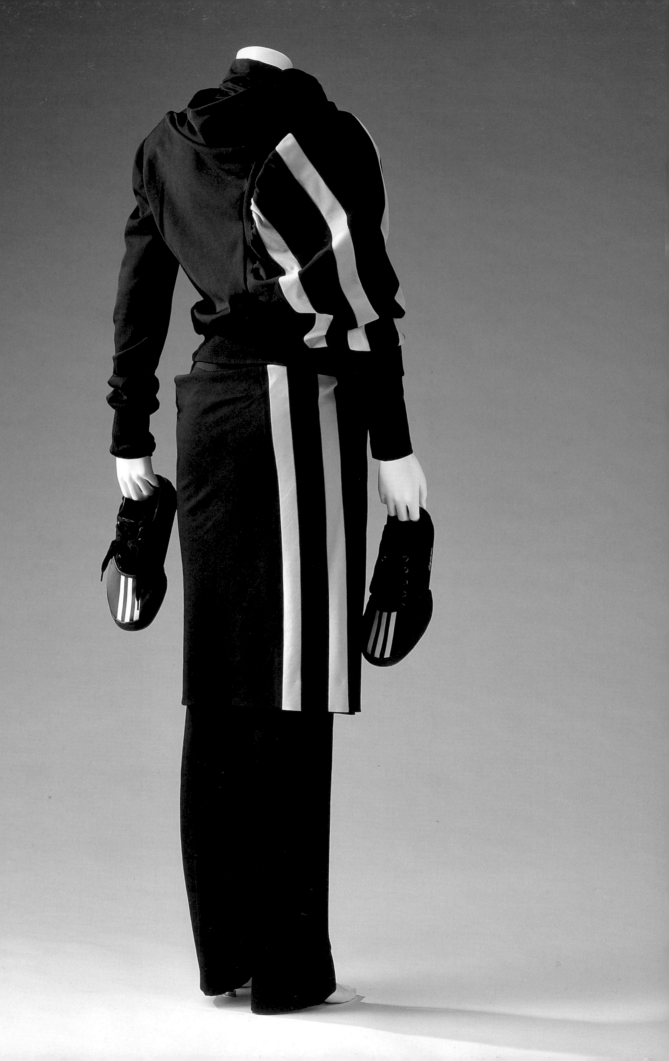

Sport and fashion meet

The influence of sport on fashion has a long history but has been particularly evident since the 1970s in the popularity of utilitarian, comfortable clothing. The tracksuit, for example, has evolved from basic keep-warm or lounging-around wear to catwalk material, as seen in Yohji Yamamoto's autumn/winter 2001/02 collection, for which the designer initiated a collaboration with the sportswear label Adidas. The products of this collaboration, while dramatically different from the couture-like garments created for his eponymous label, still feature characteristics of Yamamoto's fashion sensibility—the use of monochrome colours and inventive, asymmetrical drapery and cut. Illustrated is an outfit comprising jacket and pants in black wool gabardine emblazoned with the Adidas white stripe. Yamamoto's preference for irregularity in design is seen in the jacket, which has an inset sleeve on the left while on the right a seam is constructed to give the appearance of a sleeve. The pants are overlaid with a wrap skirt, a gender-ambivalent feature characteristic of the designer's work. In the press release accompanying this collection Yamamoto noted, 'It's not about approaching high technology itself … It's about approaching a world made of elements opposed to the ones of fashion.' For all their complexity, the deconstructed outfits have a relaxed, casual appearance that give sportswear a glamorous, distinctive edge.

1. Yohji Yamamoto (ed Carla Sozzoni), *Talking to myself*, Yohji Yamamoto, Milan, 2002.
2. Interview with Yohji Yamamoto by Susannah Frankel, *Guardian Weekend Fashion Special*, 28 September 1996, p 4. Quoted in Claire Wilcox (ed), *Radical fashion*, London, Victoria and Albert Museum, 2001.
3. Yamamoto, op cit.

(*Opposite*) **Adidas outfit**
Autumn/winter 2001/02
Jacket, pants and skirt
Wool
COLLECTION: KYOTO COSTUME INSTITUTE AC11045, GIFT OF YOHJI YAMAMOTO
PHOTO: TAKASHI HATAKEYAMA, COURTESY KCI

(*Above right*) **Yohji Yamamoto autumn/winter 2001/02 collection parade**
PHOTO: COURTESY FIRSTVIEW

FURTHER READING

Baudot, François. *Yohji Yamamoto*, Thames and Hudson, London, 1997

Bénaïm, Laurence. *Issey Miyake*, Thames and Hudson, London, 1997

Black, Sandy. *Knitwear in fashion*, Thames and Hudson, London, 2002

Bolton, Andrew. *The supermodern wardrobe*, V & A Publications, London, 2002

Braddock, Sarah, E and O'Mahony, Marie. *Techno textiles: revolutionary fabrics for fashion and design*, Thames and Hudson, London, 1998

Breward, Christopher. *Fashion*, Oxford University Press, Oxford, 2003

Chandès, Hervé (ed). *Issey Miyake making things*, Foundation Cartier, Paris, 1999

English, Bonnie (ed). *Griffith University's Tokyo Vogue: Japanese/Australian fashion* exhibition publication, Griffith University, Brisbane, 1999

Foissy, Marie-Pierre, Akiko, Fukai, Golbin, Pamela et al. *XXIème ciel mode in Japan*, exhibition book, 5 Continents Editions, Milan, 2003

Frankel, Susannah. *Visionaries: interviews with fashion designers*, V & A Publications, London, 2001

Frisa, Maria Luisa and Tonchi, Stefano (eds). *Excess: fashion and the underground in the '80s*, Edizioni Charta, Milan, 2004

Grand, France. *Comme des Garçons*, Thames and Hudson, London, 1998

Hiesinger, Kathryn B and Fischer, Felice. *Japanese design: a survey since 1950*, Philadelphia Museum of Art in association with Harry N Abrams, Inc, New York, 1994

Holborn, Mark. *Issey Miyake*, Taschen, Cologne, 1995

Kawamura, Yuniya. 'The Japanese revolution in Paris fashion' in *Fashion Theory: The Journal of Dress, Body & Culture*, volume 8 issue 2, June 2004

Koren, Leonard. *New fashion Japan*, Kodansha International, Tokyo, 1984

McCarty, Cara and McQuaid, Matilda. *Structure and surface: contemporary Japanese textiles,* The Museum of Modern Art, New York, 1998

Meij, Ietse (ed). *Yoshiki Hishinuma*, Waanders, Zwolle, 1999

Mendes, Valerie and de la Haye, Amy. *20th century fashion*, Thames and Hudson, London, 1999

Miyake, Issey. *East meets west*, Heibonsha, Tokyo, 1978

Miyake, Issey with Penn, Irving. *Issey Miyake: photographs by Irving Penn*, New York Graphic Society, Boston, 1988

Miyake, Issey, Fujiwara, Dai and Kries, Mateo. *A-Poc making: Issey Miyake and Dai Fujiwara*, Vitra Design Museum, Berlin, 2001

Otsuka, Yoko. *Tokyo designers*, Tokyo, 1999

Sudjic, Deyan. *Rei Kawakubo and Comme des Garçons*, Rizzoli, New York, 1990

Suita, Yasuko (ed). *Hanae Mori: The Iron Butterfly*, Kodansha International, 1992

Teunissen, José. *Made in Japan*, Centraal Museum, Utrecht, 2001

Wada, Yoshiko Iwamoto. *Memory on cloth: shibori now*, Kodansha International Ltd, Tokyo, 2002

Wilcox, Claire (ed). *Radical fashion*, V & A Publications, London, 2001

Yamamoto, Yohji and Washida, Kiyokazu. *Talking to myself by Yohji Yamamoto*, Steidl Publishing, Göttingen, 2002

ACKNOWLEDGMENTS

The cutting edge exhibition and publication could not have been accomplished without the participation of many colleagues and friends. Firstly, I'd like to acknowledge and thank the Kyoto Costume Institute (KCI) for their support as a major lender and collaborator. In particular, I wish to acknowledge the unflagging commitment of Akiko Fukai, director and chief curator of KCI, and her amazingly efficient staff: Tamami Suoh, Rie Nii, Atsuko Miyoshi and especially Makoto Ishizeki. Their response to my endless enquiries was always generous.

For the production of the book I wish to acknowledge contributors Bonnie English and Akiko Fukai as well as my colleagues at the Powerhouse Museum: Lindie Ward for directing and styling the Powerhouse photography; photographers Marinco Kojdanovski, Sue Stafford and Sotha Bourn; Michael Desmond and Claire Roberts for sound advice and for reading and commenting on the manuscript; Danny Jacobsen for graphic design and the lovely cover; Linda Brainwood for picture research; Anne Savage for editing; and my sincere thanks to Julie Donaldson, publications manager, for steering this publication.

For the production of the exhibition I'd like to acknowledge the contributions of many colleagues at the Powerhouse Museum, in particular exhibition designer Claudia Brueheim; exhibition coordinator Rebecca Bushby; conservator Suzanne Chee; registration staff Kate Scott, Emma Nicol and Myfanwy Eaves; Virginia Lovett, Christine Taylor and Jo Dunlop for publicity and marketing; Helen Whitty and Maki Taguchi for coordinating the Tokyo Recycle public program; Gara Baldwin for copyright clearance; Ryan Hernandez; Melanie Cariss for label editing; and Kathleen Phillips for AV production. A special thanks to Brad Baker, Manager Exhibitions Department, Mark Goggin, Associate Director Programs and Commercial Services and Jennifer Sanders, Deputy Director Collections and Exhibitions, for their support and enthusiasm.

I wish to also acknowledge the support of volunteers in the decorative arts and design department: Clare McGrath, Clare Ainsworth and Elizabeth Hawley, and in particular Shizuka Fujimoto and Wendy Circosta. I was also grateful to receive advice and support for the project from Lee Lin Chin, Gene Sherman, Akira Isogawa and Liz Williamson.

To colleagues in sister institutions within Australia, I thank Robert Bell, Gael Newton, Charlotte Galloway at the National Gallery of Australia and Robyn Healy and Roger Leong at the National Gallery of Victoria.

In Japan I'd like to thank the designers themselves. I am particularly grateful to Junichi Arai, Yoshiki and Hisae Hishinuma, Reiko Sudo and Keiji Otani, Hiroaki Ohya, Yoko Otsuka, Kosuke Tsumura, Jun Takahashi and Aiko Inoue, Kimi Wada at Comme des Garçons, Masahiro Nakagawa, Shinichiro Arakawa, Nozomi Ishiguro, Aya Tsukioka, Hiroko Watanabe and Yoshiko Iwamoto Wada.

Financial support from the Gordon Darling Foundation, the Suntory Foundation and the Japan Foundation was gratefully received as was support in-kind from JAL and our exhibition media partners *marie claire* and SBS Radio.

Finally, thanks to Peter, Nicholas, Oliver and Rosalie Pether.

Louise Mitchell

ABOUT THE AUTHORS

Louise Mitchell is a curator of decorative arts and design at the Powerhouse Museum—responsible for the international fashion, textile and jewellery collections—and the curator of *The cutting edge: fashion from Japan*. Her previous publications include *Stepping out: three centuries of shoes* (ed), Powerhouse Publishing, 1997 and *Christian Dior: the magic of fashion* (ed), Powerhouse Publishing, 1994, as well as contributions in *Decorative arts and design from the Powerhouse Museum* (Powerhouse Publishing, 1991) and *Heritage: the national women's art book* (An Art and Australia Book, 1995).

Bonnie English is senior lecturer in Art and Design Theory and a past deputy-director at the Queensland College of Art, Griffith University, Brisbane. Her teaching and research interests include modernist and postmodernist design theory and the inter-relationship of fashion and art. English won a national multimedia ASCILITE award in 1997 for the *Fashion and art* CD-ROM. She co-curated Griffith University's *Tokyo Vogue* exhibition held in Brisbane in 1999. Bonnie is currently working on the forthcoming book *A cultural history of fashion in the 20th century* (Berg Publishers, Oxford, due for publication in 2007).

Akiko Fukai is the director/chief curator of the Kyoto Costume Institute (KCI) and has worked there since 1979. She has curated the following exhibitions: *Revolution in fashion 1715–1815*; *Japonism in fashion*; *Visions of the body: fashion or invisible corset*; and *Fashion in colours: Viktor & Rolf & KCI*. All exhibitions had accompanying publication with essays written by Akiko Fukai. Akiko Fukai also contributed an essay on Japanese fashion to *Ptychoseis: folds and pleats* published in association with the exhibition of the same title held at the Benaki Museum in Athens in 2004.

ABOUT THE MUSEUMS

Powerhouse Museum, Sydney

The Powerhouse Museum is Australia's largest museum. Part of the Museum of Applied Arts and Sciences established in 1880, the Powerhouse Museum was purpose-built in 1988 in and around a disused power station. Its collection spans decorative arts, design, science, technology and social history, which encompasses Australian and international, and historical and contemporary material culture. The Powerhouse Museum has a reputation for excellence in collecting, preserving and presenting aspects of world cultures for present and future generations.

The Powerhouse has one of Australia's most extensive textile and fashion collections. The collection ranges from samplers, embroideries and fine dressmaking, to textiles from around the world, and historical and contemporary costume and fashions by significant international and Australian designers. In 1997, the museum opened its Asian Gallery with the aim of promoting a greater awareness and appreciation of Asian cultures in Australia. Previous exhibitions in the gallery include: *Evolution & revolution: Chinese dress 1700s–1990s* (1997); *Rapt in colour: Korean costumes and textiles from the Choson dynasty* (1998); *Beyond the Silk Road: arts of Central Asia* (1999); *Trade winds: arts of Southeast Asia* (2001); and *Fruits: Tokyo street style* (2002).

Kyoto Costume Institute

Founded in 1978, the Kyoto Costume Institute (KCI) holds one of the world's most extensive clothing collections and has curated many exhibitions worldwide such as *Revolution in fashion 1715–1815, Japonism in fashion, Visions of the body*, and *Fashion in colours*, collaborating with other institutions. With an emphasis on Western women's clothing, the KCI has amassed a wide range of historical garments, underwear, shoes, and fashion accessories dating from 18th century to the present day. In 2002, the KCI published *Fashion: a history from the 18th to the 20th century, collection of the Kyoto Costume Institute* with Taschen, which has been translated into 10 languages.